M000237516

IMAGES
of America

CRYSTAL LAKE, TOLLAND COUNTY

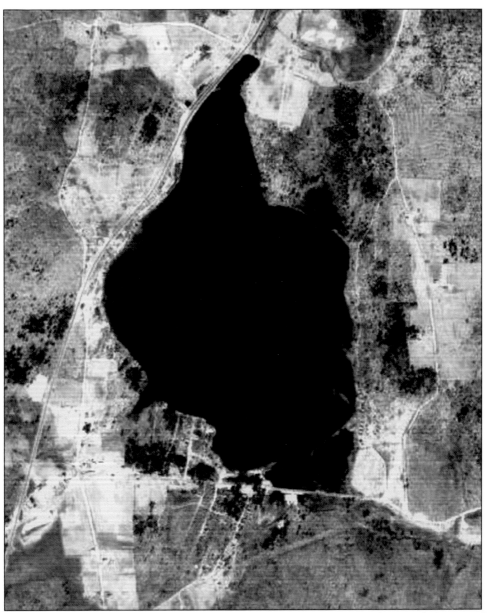

Connecticut became the first state to complete a statewide aerial survey. This aerial photograph of Crystal Lake was taken in April 1934. On September 21, 1938, students in the two-room Crystal Lake School, the white square on the southeast corner of the lake, would watch as every pine tree in the Sandy Beach grove was destroyed by hurricane-force winds. (Courtesy of Digital Collections, Connecticut State Library, detail of photograph 02161.)

On the cover: Cousins Elsie Liebe and Cora Markert (right) pose in this *c.* 1916 photograph on Baker's beach on the northeast shore of the lake after returning from a paddle in their Old Town sponson canoe. They made their own wool bathing costumes with knee-length skirts, striped trim, and swim bonnets. Note the stockings and shoes that complete the outfits. (Courtesy of Adelaide Menge Campbell.)

IMAGES
of America

CRYSTAL LAKE, TOLLAND COUNTY

Lynn Kloter Fahy
for the Crystal Lake Historical Society

ARCADIA
PUBLISHING

Published by Arcadia Publishing
Charleston, South Carolina

Printed in the United States of America

Library of Congress Control Number: 2008936834

For all general information contact Arcadia Publishing at:
Telephone 843-853-2070
Fax 843-853-0044
E-mail sales@arcadiapublishing.com
For customer service and orders:
Toll-Free 1-888-313-2665

Visit us on the Internet at www.arcadiapublishing.com

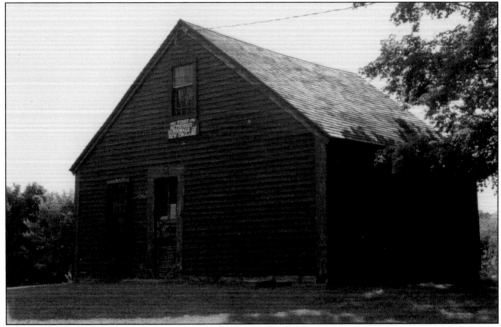

The Crystal Lake Historical Society was established at a meeting at the Community House on Sandy Beach Road on September 9, 1984. The 34 attendees of the first meeting recognized the need for preserving and promoting the history of the lake community. Officers elected were president Chrystal Montgomery, vice president Agnes Limberger, treasurer Donald Neff, and secretary Edna Edwards. Limberger is the current president and has served faithfully for many years. The society has undertaken the restoration of the first Methodist parsonage in New England, pictured, which was built in the 1790s.

CONTENTS

ACKNOWLEDGMENTS

I remember visits to my maternal grandparents' summer cottage on Lakeview Avenue, overlooking Crystal Lake. They walked down the hill with me to Earl and Agnes Rich's Triangle Grocery or along White Road for a swim at Sandy Beach and a Popsicle at Jimmy's. I am grateful to Reginald and Elsie Morrell Kent for these warm memories of summer at the lake.

When I was asked by Chrystal Montgomery of the Crystal Lake Historical Society if I would consider writing an Images of America history on the lake, I knew that there were few photographs in our town's museum and library. However, I spent many pleasant hours with current and former residents who were eager to share their family photographs and memories with me. I even had a hamburger cooked by Ken Wendell for me on the former Wadena cottage's fireplace, which is all that remains of his family's many cottages.

The following individuals and organizations contributed to the book: Shirley Liebe Andrews; Barry Andrews; Cheri and Fred Arzt; Hazel Dimock Bedard; Fred Bird, photographer; George "Toot" Bokis; Alice Peterson Williams Bosworth; Adelaide Menge Campbell; Ted Conklin; Terry Smith Coulombe; Crystal Lake Historical Society; Joan Duell; Cliff Edwards; Mary Fahy; Ellington Historical Society; Dave Gauthier; Marjorie Willis Gilbert; Judith Grimaldi; Russ Johndrow and Sandi LaChappelle of Russ's Time Restaurant; Betty Bonan Judge; Diane Judge Peskurich; ProQuest Historical Newspapers, *Hartford Courant* (1764–1922 and 1923–1984); Lucille Kuhnly; Agnes Minor Limberger, president of the Crystal Lake Historical Society; Julianna Rogalla MacGregor for the Gross family photographs; Bob Minor; Chrystal Skinner Montgomery; Walter "Rusty" Moody of the Crystal Lake Yacht Club; Matt Murphy, teacher at the Crystal Lake School; Pauline Soukup Page; Beth Kloter Parkes; Sue Phillips, director of the Hall Memorial Library; Agnes Willis Rich; Jack Rich; Margaret "Mig" King Sertl; Shirley Hayden; Pamela Strohm-Gorden; Richard Tambling of the *Journal Inquirer*; Phil Tolisano; Charlotte Ludwig Trench; Ken Wendell; Roy Wendell Jr.; and Thomas Zaharevich.

I would also like to thank my editor at Arcadia Publishing, Hilary Zusman, and my husband, Tim Fahy, president of the Ellington Historical Society. Not only does Tim read and comment on my writing, but he cooks dinner for me every night.

INTRODUCTION

Crystal Lake is located in the towns of Ellington and Stafford in Tolland County. It lies in a five-mile corridor between Stafford and Tolland that extends eastward from the lowlands of Ellington. Although the Crystal Lake section is part of the town of Ellington, it maintains its own identity. The towns are changing and growing in the 21st century, and they are moving beyond Ellington's farming and Stafford's textile mill origins. Estimated populations in 2007 were 15,107 for Ellington and 12,389 for Stafford. Many of the lake's remaining cottages have been converted into year-round homes as a year-round community has settled into the former summer resort.

Historic artifacts found at the northern end of the lake provide evidence of an ancient Nipmuc Indian village. These Native Americans called the lake Wabbaquasset, which means "flaggy pond," for the cattails that grew there. Early white settlers called it Square Pond for its shape or Ruby Lake for the garnets in the surrounding hills. In 1889, the name was officially changed to Crystal Lake. The sandy shore and the surrounding forests of oak, pine, chestnut, and maple attracted the Dimock, Richardson, Newell, and Aborn families to the lake in the early 1800s. They were living there when the last Native Americans left after a Native American named George Henry Washington was hanged for the murder of his wife in 1824. Descendants of the Richardson and the other three founding families still live in the area and remain a vital part of the lake's history. Merrick Abner Richardson, son of Warren Richardson and Luna Dimock, recalled his "laughing, frolicking, romping" childhood at the lake in his 1917 biography, *Looking Back*. He moved to Chicago, where he built a successful copper and tinware manufacturing company and traveled the world.

Methodism flourished at Crystal Lake at the end of the 18th century, and the Crystal Lake Methodist Church built the first Methodist parsonage in New England in 1791 for the "saddlebag" preachers who followed the Hartford circuit to deliver Sunday sermons to small communities. The parsonage was moved in 1966 to the crest of the hill across from the church and is being restored by the Crystal Lake Historical Society. Methodist camp meetings in the early 19th century were promoted as a way to increase religious fervor, but they became a way for people to socialize economically. Such a meeting was held at Crystal Lake in 1806, and thousands attended.

In contrast to the spartan conditions of camp meetings, hotels and resorts were built to accommodate the tastes of Americans who were increasingly in search of rest and recreation. The word *vacation* did not enter the common vocabulary until the 1850s. Crystal Lake became a destination resort in the late 1890s, and its popularity spanned the era of the interurban trolley

and the Depression-era auto-trippers who stayed in the newly built roadside tourist cabins. The Crystal Lake Hotel formally opened in 1894 on the west shore of the lake, on property known as Dimmick's Grove, a variation of the spelling of the Dimock family name. Sandy Beach, on the south shore, part of the Lucius Aborn farm, was developed into a public beach and amusement park in the 1920s. Interurban trolley service from Rockville to Stafford in the 1920s made the lake accessible to residents of Stafford and Rockville who built cottages at the lake. A dance hall and boxing arena were added, and by the 1930s, the Sandy Beach Ballroom was attracting big band names such as Duke Ellington, Guy Lombardo, and Cab Calloway. The ballroom also served as a roller-skating rink where many young people from Ellington, Stafford, Rockville, and surrounding towns spent their leisure hours. In 1930, the summer colony was described by historian Alice Pinney as a "miniature Coney Island."

A second dance hall, built by Conrad Rau in 1915, was located on the west shore. Later known as Jack's and the Clearwater Beach Club, the property was bought in 1976 by singer Gene Pitney, the "Rockville Rocket," who was inducted into the Rock and Roll Hall of Fame in 2002. He changed the name to the Crystal Lake Beach and Boat Club. Having grown up in nearby Rockville, he had worked in the club's snack bar as a teenager. Pitney and a partner turned the property into a private beach club. A third ballroom, the Crystal Ballroom, was built in 1946 and attracted crowds with its polka orchestras.

Jimmy's hot dog stand on Sandy Beach Road served four generations of customers. Started by James Gross in 1929 after his Hartford business collapsed, it survived until his daughter Shirley's retirement in 2004. Winter was busy on the lake, with ice-harvesting, iceboating, ice-skating, and ice-fishing. Summer activities included canoe carnivals, sailboat races sponsored by the Crystal Lake Yacht Club, fishing, and swimming.

The Town of Ellington bought Sandy Beach in 1971 and provides beach activities in the summer. Fishing is still excellent at the lake, attracting many anglers every year. The lake was designated a trophy trout lake in 1993 and brood stock Atlantic salmon were stocked in the fall of 2007 by the Connecticut Department of Environmental Protection. The lake was chosen to be stocked with trout because of its abundance of alewives, which are good food for trout. Boaters have access to the lake at the state boat launch on the west shore.

A one-room schoolhouse built in 1861 became a two-room school for eight grades in 1929. As enrollment increased, only the first two grades remained in the schoolhouse, while the older grades were bused to Longview School. Crystal Lake parents who did not want their children to have to travel to the downtown school banded together and formed a committee to build a new school at the lake. A new Crystal Lake School was completed in 1957 and celebrated its 50th anniversary in 2007.

The Town of Ellington and the Crystal Lake Association joined in 1993 to create Veteran's Memorial Park on the triangle of land at the intersection of West Shore Road, Sandy Beach Road, and South Road, where a bronze plaque honors the 49 Crystal Lake men and 1 woman who served in World War II. The uniqueness of the lake community and its distance from downtown Ellington led to the formation of a second historical society in the town of Ellington. The Crystal Lake Historical Society was organized in 1984 in time to enter a float in Ellington's bicentennial parade in 1986. The society marks its 25th anniversary in 2009 with the publication of *Crystal Lake, Tolland County.*

One

THE WABBAQUASSET MOUNTAIN HOME

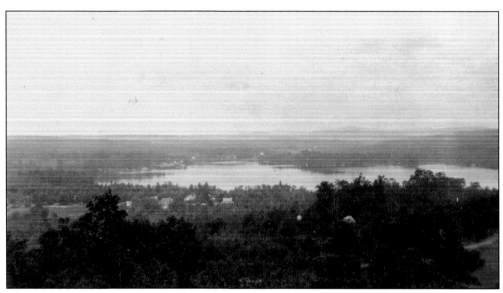

The Native American Nipmuc tribe called the lake Wabbaquasset, which means a place where cattails grow. Early settlers called it Square Pond or Ruby Lake for the garnets in the outcroppings in the rocks. Artifacts found on the north shore of the lake, near where the Stafford dam is now, reveal that an ancient Nipmuc village lay there. They also made cooking pots of steatite, or soapstone, from nearby Soapstone Mountain. Native Americans still lived on the south shore when the Dimocks, Richardsons, Newells, and Aborns came to settle by the lake. The few that remained left after the hanging of a Native American known as Wappa for the murder of his wife in 1824. He was hanged on a hill on the north end of the Tolland Green, a half mile from the courthouse, before a crowd of 10,000 people, according to an account in the *Connecticut Courant*.

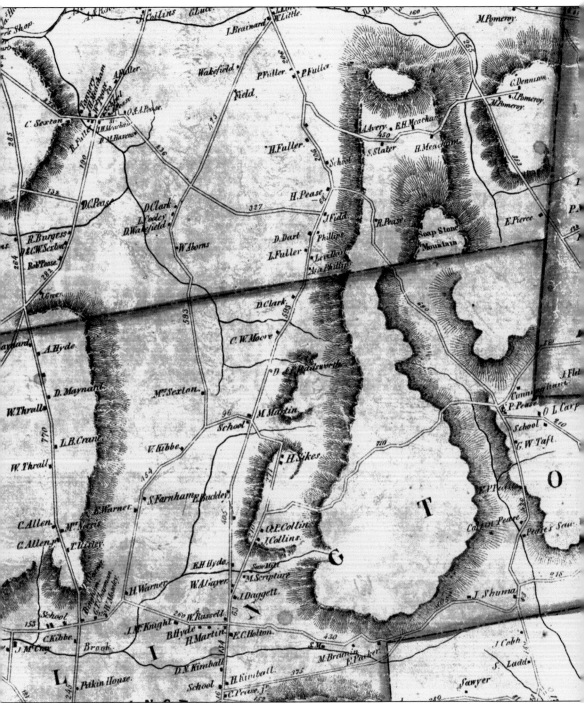

Crystal Lake was still called Square Pond when this 1857 map was drawn from surveys by W. C. Eaton and H. C. Osborn. The name was officially changed to Crystal Lake in 1889. It lies in a narrow strip of land between Tolland and Stafford that extends from the northeast corner of Ellington and is bounded on the east by the Willimantic River. Called the Equivolent, it was transferred to Ellington's parent town of Windsor in 1716 as compensation for land taken from

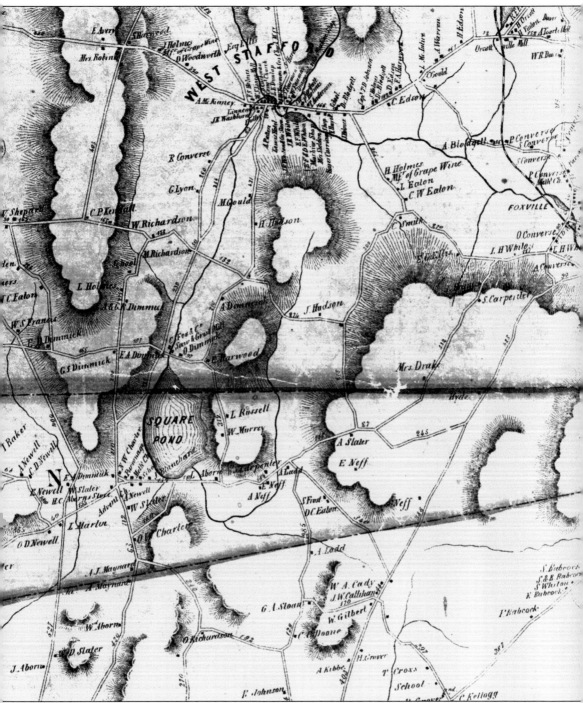

Windsor's northern borders in a dispute between Connecticut Colony and Massachusetts Bay Colony. Warren Richardson's Wabbaquasset mountain home is marked in the middle of the top of the map. Soapstone Mountain is on the upper left. The Methodist church and the Advent church stood on opposite sides of the road on the southwest corner of Square Pond.

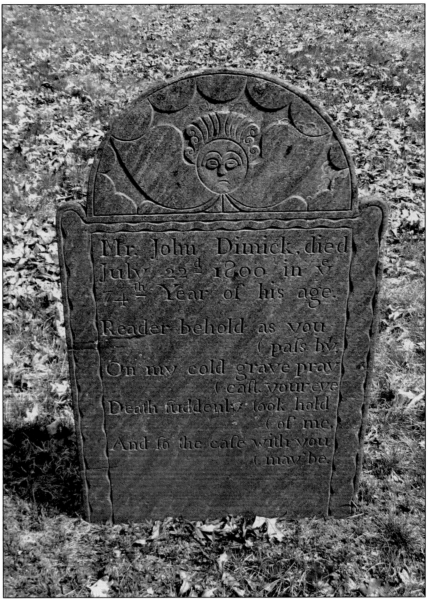

On the gravestone:

Mr. John Dimick, died
July 22ᵈ 1800 in ẙ
74ᵗʰ Year of his age.

Reader behold as you
(pafs by,
On my cold grave pray
(caſt your eye
Death ſuddenly took hold
(of me,
And ſo the cafe with you
(may be.

John Dimick and his wife, Hannah Smith, settled in Stafford in 1754. Dimick served as a cook in the Revolutionary War army. His bones lie beneath this gravestone in the Old West Stafford Cemetery. One of John Dimick's 10 sons, Abner Dimock built his home on the west side of the lake. John Richardson built his home on the east side of the Devil's Hopyard, a swamp to the east of the lake. Dimock raised six girls and one boy. Richardson raised a family of five boys and one girl. Merrick Richardson wrote of his grandparents: "Warren Richardson crossed the Hopyard, wooed and won Luna Dimock, and they built their nest near Wabbaquassett Lake, where the flowers bloom in the early spring, wild birds awake the summer morn and the babbling brook sings through the winding vale below, all day long." They raised eight children: Mariette married Frank Slater, Eliza married Lucius Kibbe, Adelia married Epaphro Dimock, Caroline married Lucius Aborn, her twin Collins married Martha Aborn, Merrick married Mary Hoyt, Gordon married Amanda Pitt, and Janette married George Newell.

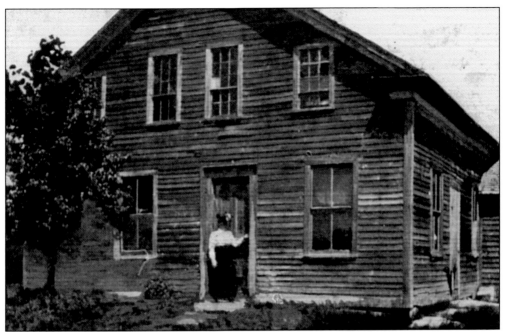

This house was built on a hill to the west of Wabbaquasset in 1832 by Warren Richardson, who married Luna Dimock after they built and furnished their home. Warren bought 350 acres on which to build his house and barn. Luna, pictured at her front door, earned money to furnish the house by braiding palm leaf hats for the slaves of Southern planters.

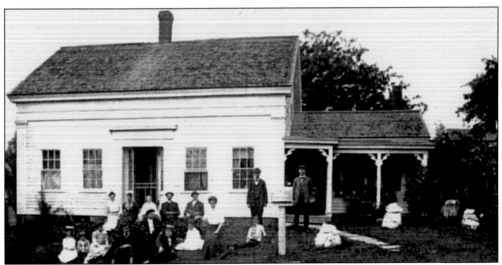

Caroline Richardson and her husband, Lucius Aborn, welcomed family in this c. 1880 photograph taken at their home at the lake. Lucius was a registrar of voters, a selectman, and a member of the school board. At the time of his death in 1916 at the age of 77, he was the oldest director of the Stafford Springs Agricultural Fair Association. This house on Skinner Road is still standing.

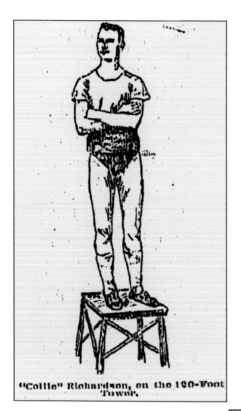

"Collie" Richardson, on the 120-Foot Tower.

The headline of an article in the July 23, 1894, issue of the *Hartford Courant* read "Hundreds Saw Him Die. Collins R. Richardson Killed at Crystal Lake." Twenty-four-year-old Crystal Lake native "Collie" Richardson had jumped to his death from a 120-foot-high tower into 12 feet of water, which was actually at Pine Point Grove, Shaker Station, Enfield, before a paying crowd of 700 people.

Collins Richardson was buried in Crystal Lake Cemetery in Stafford. His parents, Collins and Martha Aborn Richardson, and several brothers and sisters survived him. The newspaper account of the tragedy said that he came from a family of swimmers including his 13-year-old sister Bessie, who was present at the fatal dive. He was attempting to better the record he set two weeks earlier, when he dove from a 100-foot tower.

Ira H. Lewis, a blacksmith, served in the Connecticut General Assembly and local offices and was a member of the Advent Church. In 1865, Lewis and his wife, Alice Ann Foster, bought a farm on South Road from Ebenezer Harwood. His daughter Hattie recalled that, shortly after they moved in, a neighbor came to the door shouting "Iry! Iry! They've shot the president," as he waved a newspaper reporting Abraham Lincoln's assassination.

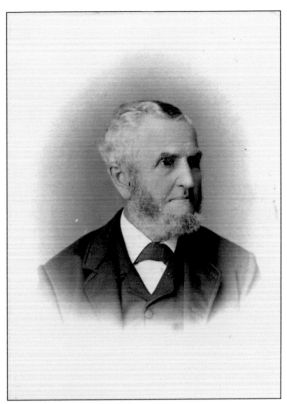

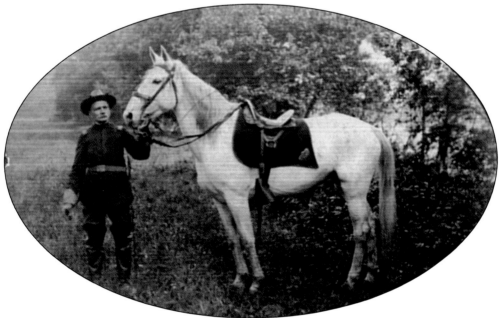

Lucius Henry Lewis, son of Ira and Alice Foster Lewis, served in Company C of the 22nd Regiment Connecticut Volunteers Infantry in the Civil War. This photograph was taken after he enlisted on August 25, 1862. He served until July 7, 1863, and went into the clothing business in Hartford after the war.

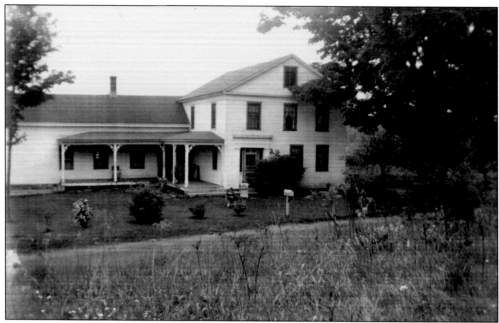

Ira Lewis's daughter Hattie married Alfred Uriah Charter in 1871 and went to live in the Charter family homestead on Crystal Lake Road, formerly called Lake Bonair Road. Their daughter Hazel married Edward Ludwig. Two of the Ludwigs' children, Donald (left) and Charlotte, are pictured on the front lawn around 1940.

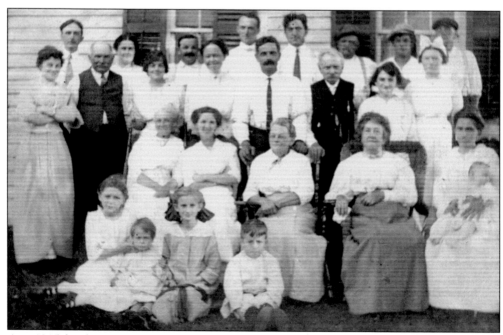

A c. 1915 family reunion at the Charter homestead brought together Charters, Lewises, Neffs, Ludwigs, and Darceys. The matriarchs of the families are (second row, seated) Jennie Lewis Neff (left) and her sister Hattie Lewis Charter (third from left). Neff had three children and Charter had six children, so a reunion brought together an impressive group.

Alfred Uriah Charter is pictured in front of the family homestead around 1921 at the time of his golden wedding anniversary. He was the fourth generation of Charters to live in the house. He served as a selectman for 12 years, a justice of the peace, and a representative to the Connecticut General Assembly in 1888. Charter was born here in 1848 and died in the same room in 1929.

Hattie Lewis Charter, pictured here around 1921, was born in Stafford, but moved to Crystal Lake after her marriage and lived there until her death in 1935 at the age of 79. She was a member of the Crystal Lake Community Methodist Church and the president of its ladies aid society for 26 years. She also was the correspondent from the lake community to the *Rockville Leader* for 30 years.

Myron Harlem Dimock was born in July 1852 at Square Pond. He was a ninth generation descendant of Thomas Dimick or Dymoke, born in England in the 16th century and a descendant of the Dymokes of Scrivelsby, King's Champions of England. Thomas and his wife Ann sailed aboard the ship *Hopewell* from Weymouth, England, to Massachusetts Bay in 1635. They settled first in Dorchester, where he was elected selectman.

Myron Dimock married Emma Lucelia Newell, pictured here, in November 1877. Emma was born in October 1857. Myron was named postmaster at Square Pond in 1884 and served until 1908. He was also a schoolteacher and taught many of his and Emma's nine children at the one-room Crystal Lake School on the corner of White Road and Sandy Beach Road.

Orrin D. Newell, pictured here in an undated photograph, was born in 1828. He was the father of Emma Newell Dimock. According to the 1857 map of Square Pond, Newell and his wife Emily Taft lived on Lake Bonair Road. Sanford Charter and his wife Ruth Webster, third generation occupants of the Charter homestead, and their 16 children were neighbors.

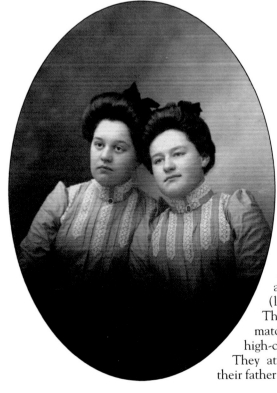

Among the nine children born to Myron and Emma Newell Dimock were twins Elna (left) and Lena, born on August 24, 1885. They pose together for this photograph with matching Gibson Girl pompadour hairstyles and high-collared dresses with lace trimmed bodices. They attended the one-room schoolhouse where their father was the teacher.

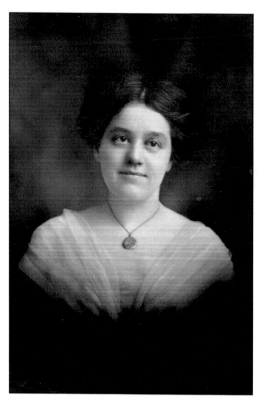

Lena Dimock sat for this *c.* 1900 photograph wearing a dress with a bodice and sleeves of softly pleated chiffon. She married Claude Perkins Bilson. He worked at the White-Corbin Division of the United States Envelope Company in Rockville and retired in 1956 after 45 years of employment. The Bilsons had a cottage at Crystal Lake.

Lena Dimock's twin, Elna, pictured here in a white dress with a high stand collar and bodice embellished with a detailed hemstitched pattern and pin tucks, married Everett Charter, a son of Alfred and Hattie Lewis Charter. Her older sister Edna married Everett's brother Harry, creating strong ties between the Dimock and Charter families.

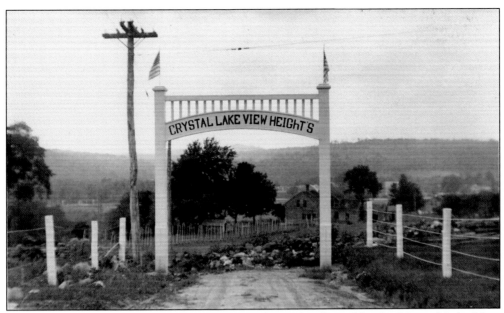

Jennie Lewis Neff's 18th-century house on South Road is framed by the "Crystal Lake View Heights" sign in this view from Lakeview Avenue. Crystal Lake Center Cemetery is just visible over the roof, and a row of pole beans in Neff's garden can be seen to the left of the farmhouse.

Jennie Lewis Neff and her husband Eugene B. Neff lie in the Crystal Lake Cemetery in Stafford. Born in 1860, the year that Abraham Lincoln was elected president, Jennie first voted in 1920 after the 19th Amendment to the United States Constitution extended suffrage to women. She voted in the 1952 election between Dwight D. Eisenhower and Adlai Stevenson when she was 92 years old.

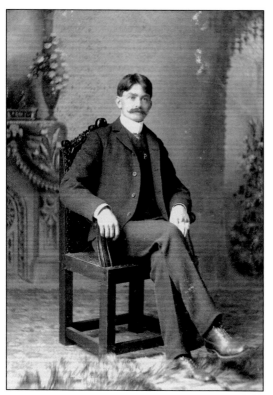

On July 13, 1898, 100 ladies gathered at the Grand Army of the Republic hall in Rockville to sew clothing and bandages for Spanish-American War soldiers. Perlin Lewis Charter, pictured here around 1895, was the son of Alfred and Hattie Charter. Pvt. Perlin Charter was mustered into service on May 17, 1898. While the ladies were sewing, he left to join Company C of Rockville before its departure for Niantic.

Thomas and Ora Charter Darcey's son Walter sits on a pony with a little help from the man hiding behind the pony. His grandparents Alfred and Hattie Charter must have loved this c. 1936 photograph of their grandson. Walter is all dressed up in his little boy bloomers and stockings, with a sweater and bonnet to keep him warm.

Hazel Charter, daughter of Alfred and Hattie Charter, pictured here at age 21, became the wife of Edward A. Ludwig on May 19, 1914. Their wedding was held at the Charter homestead on Crystal Lake Road, which had been in the family since 1753. The Ludwigs bought over 300 acres of land from Hazel's father's estate and raised a family of eight children on the farm.

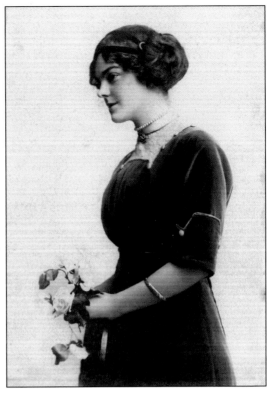

Edward A. Ludwig, pictured here around 1912, worked the Charter farm and was also employed by the Connecticut Bus Company. He served his community in many positions, including that of zoning officer. Ludwig taught a class in blacksmith technique at Camp Conner for the Civilian Conservation Corps in Somers, and he was the first fire chief of the Crystal Lake Fire Department when it was formed in 1934.

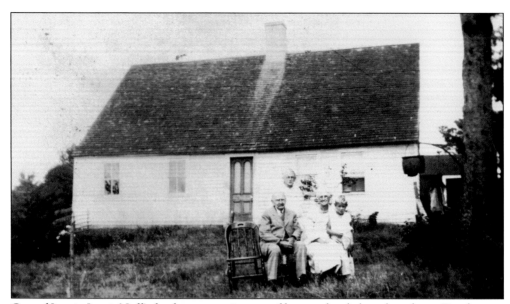

One of Jennie Lewis Neff's fondest memories was of her mother baking bread in a Dutch oven in a fireplace in the Neff farmhouse on South Road, pictured here around 1930. Her mother also used a spinning wheel to spin flax that was grown on the farm. From left to right are Eugene Neff, Hattie Lewis Charter, her sister Jennie, and an unidentified grandchild.

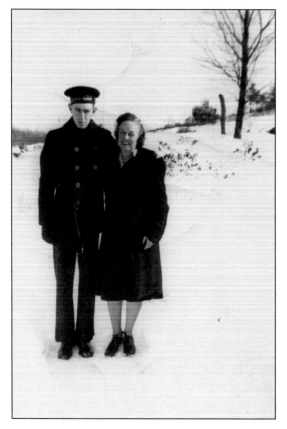

Alden Neff (left) and his mother Elsie Pfau Neff are pictured here while Alden was home on leave from the U.S. Coast Guard during World War II. Alden and his brothers Donald, Walter, and Herbert were the sons of Elsie and Warren Neff and the grandsons of Jennie Lewis Neff. The names of Alden, Donald, and Walter are listed on the plaque at Veterans Memorial Park for their war service.

Agnes Minor Limberger was one of a family of eight children born to Francis and Atalina Minor. She grew up on the Minor farm, pictured here. There were pear and apple orchards on the farm on Minor Hill Road, marked as San Juan Hill Road on the 1952 U.S. geological survey map. The orchards were destroyed in the Hurricane of 1938.

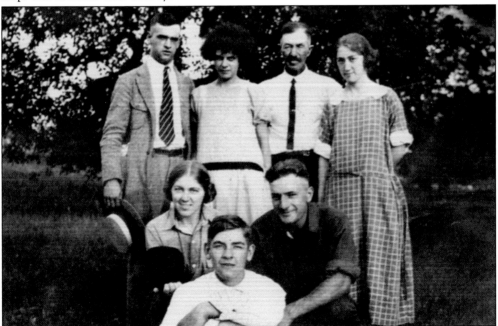

Members of the Minor family from left to right are (first row) Frederick Minor; (second row) Agnes Minor Green and Thomas Minor; (third row) Joseph Minor(?), Omilean Minor Willis, Peter Minor, and Irene Minor Peterson. Agnes was the oldest living member of the Crystal Lake Community United Methodist Church when she celebrated her 100th birthday there in January 1997.

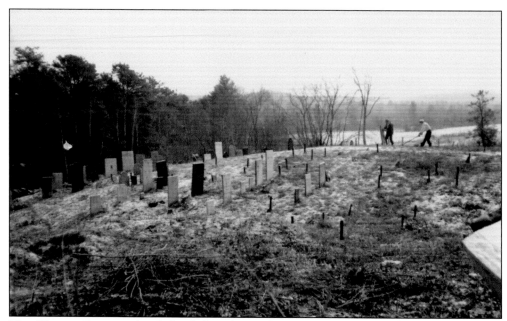

The Charter Cemetery lies behind the Charter homestead on Crystal Lake Road. The first burial took place around 1750. The Square Pond stagecoach's route passed near the cemetery in the 1800s. Several generations of Charters and other families are buried here. The two men in this photograph are working to clear the brush from around the gravestones.

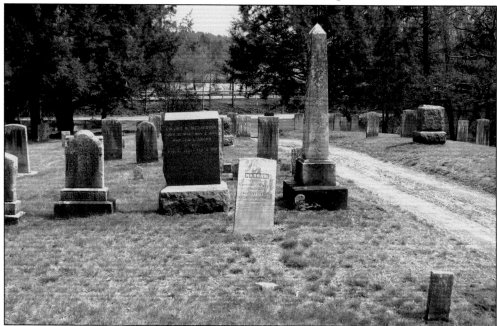

Kenneth Willis Sr., great-grandson of Orrin D. Newell, was sexton of the three Crystal Lake cemeteries for over 40 years. This cemetery, the Crystal Lake Cemetery in Stafford, was one of them. When he started, he dug the graves by hand. He took great pride in maintaining the final resting places of generations of families who settled by the lake the Native Americans called Wabbaquasset.

Two

METHODISM FLOURISHES

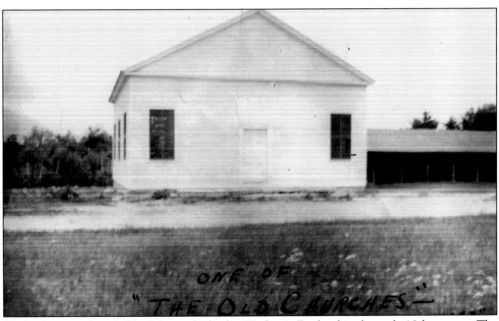

Methodism was founded by John and Charles Wesley in England in the early 18th century. The movement spread to the colonies and was bolstered when John Wesley sent Francis Asbury and others to America in 1771. Asbury became the most important figure in early American Methodism. In December 1784, at the Christmas conference of preachers held in Baltimore, the growing movement organized as the Methodist Episcopal Church in America. Bishop Francis Asbury charged the Rev. Jesse Lee with introducing Methodism to New England. In the spring of 1790, Lee came to the lake known as Square Pond. According to Ellington land records, the first meetinghouse was built on land leased from Allen Charter and dedicated in 1792. After Sunday services on March 3, 1833, it was destroyed by a fire that originated in a stove. The second meetinghouse of the Crystal Lake Community Methodist Church was built in 1834 on Ephraim Dimmick Jr.'s land on Sandy Beach Road. This photograph was taken after the horse sheds in the photograph were added around 1906 by the ladies aid society.

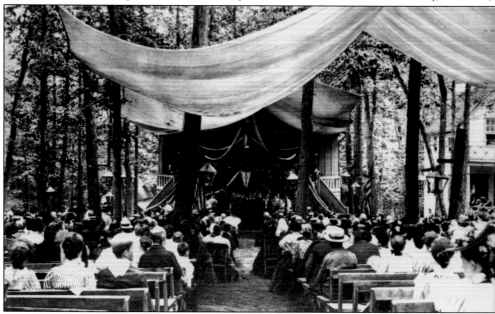

At a meeting of the subscribers for the erection of a meeting house for the Methodist Episcopal Society in Ellington & Stafford near Square Pond legally warned & held at the dwelling house of Solomon Eatons in Ellington on Friday the eighth of Dec 1833 Made choice of Rev Elisha Frink Moderator & E Dimmick Jr Clerk

Voted to appoint three persons a building committee for the subscribers —

Voted that Nathan Charter Ephraim Dimmick Jr & Ephraim Newell constitute said committee

Voted Nathan Charter Treasurer

Voted Abner Dimmick Jr Collector

After the first meetinghouse burned, a committee was formed to erect a new house for the Methodist Episcopal Society of Ellington and Stafford. A meeting was held at Solomon Eaton's house on December 27, 1833. According to the minutes, pictured, Elisha Frink was elected moderator and Ephraim Dimmick Jr. was elected clerk. Nathan Charter, Dimmick, and Ephraim Newell were appointed to the building committee. (Courtesy of the Connecticut Historical Society, Hartford.)

Square Pond hosted a camp meeting in 1806 in a grove near the lake. Methodism was flourishing, and attendance was in the thousands. As Ebenezer Washburn entered the grove, a man approached him and said that Washburn had preached the word of God into his soul the year before in Tolland, and "it remains there yet." The scene must have been like this one in nearby Willimantic. (Courtesy of the Library of Congress.)

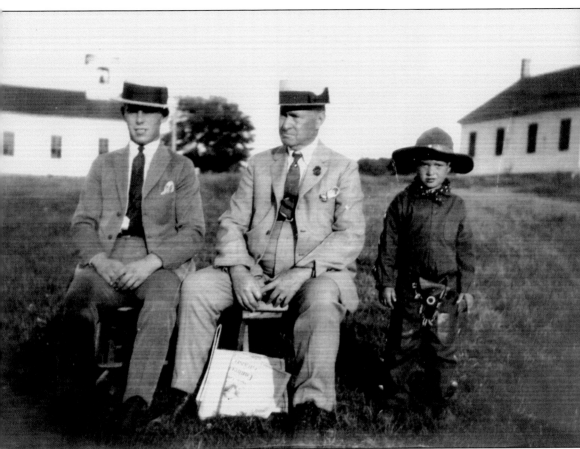

In this 1923 photograph taken at the Aborn farm, three Everetts representing three generations of Aborns pose with the Crystal Lake Community Methodist Church (left) and the Advent church in the background. From left to right are Everett Skinner; his uncle Everett Aborn, a Chicago lawyer who was born on the farm in 1859; and Everett Bradway, Skinner's nephew and Aborn's grandnephew. They were descendants of Lucius Aborn and Caroline Richardson. The Advent Church organized and built a meetinghouse in 1840 after a division arose among Square Pond churchgoers, but the community was unable to support two churches, and both churches shut their doors. Rev. O. E. Thayer, who lived at the lake, conducted services from 1887 to 1897, when Square Pond was formally attached to the Stafford Springs charge, and James I. Bartholomew became the pastor.

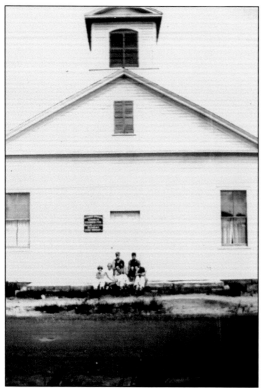

This photograph of the Crystal Lake Community Methodist Church shows the bell tower that was added to the sanctuary in the early 1900s. The bell, weighing 1,102 pounds, was purchased from McNeely Bell Company of West Troy, New York, for $294.62. Jennie Lewis Neff, born in 1860, remembered one preacher who "hollered so loud during his sermons that he could be heard a mile away."

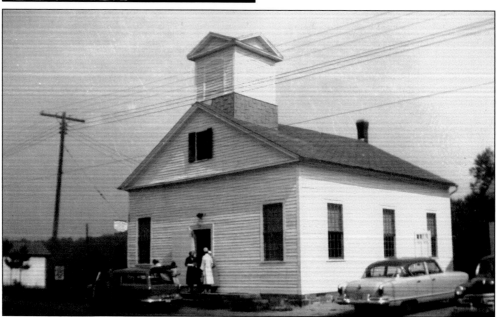

This c. 1951 photograph of the Crystal Lake Community Methodist Church was taken after the horse sheds had been removed to make way for the community house. The sanctuary was renovated during the summer of 1951 and rededicated at a ceremony presided over by Rev. Dr. John Wesley Lord, bishop of Boston. Jennie Lewis Neff, the oldest member of the church at age 91, was in attendance.

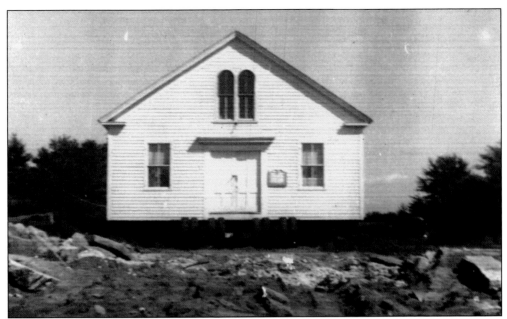

The move of the former Advent church on George Limberger's 50-foot-long trailer in September 1952 went smoothly. Cochairmen of the moving committee George Brigham and Edwin Baker, on hand to oversee the move, agreed that Limberger was such an expert that pictures on the wall were undisturbed as the truck moved the structure across the road to take its place next to the Crystal Lake Community Methodist Church.

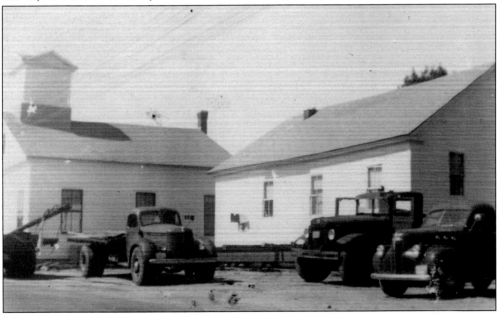

The former Advent church was moved into place and a breezeway was constructed to connect the new community house to the Crystal Lake Community Methodist Church. In the early 1900s, the Advent church, which was across the street from the Methodist church, had been remodeled and painted for the ladies aid society, which put on delicious chicken pie suppers and other activities in the building.

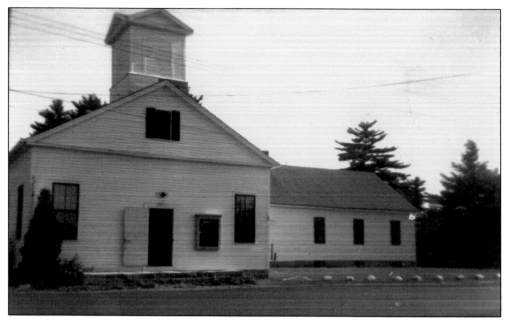

An eight-year mortgage was taken out in 1952 to move and repair the community house, pictured here in 1960. Trustees George Brigham and Bessie Neff Conklin burned the mortgage at a ceremony on March 19, 1961. When the Evangelical United Brethren Church and the Methodist Church united in Dallas in 1968 to form the United Methodist Church, the Crystal Lake church became known as the Crystal Lake Community United Methodist Church.

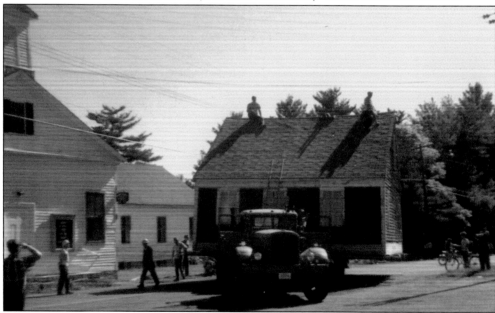

On July 19, 1966, the Methodist parsonage was moved from its location on Sandy Beach Road across the street from Jimmy's hot dog stand to its present location across from the Methodist church. Built in 1795 as an overnight rest stop for "saddlebag" preachers on the Hartford circuit who stopped at Square Pond, the parsonage passed into private ownership until it was purchased by the Crystal Lake Methodist Church in 1965.

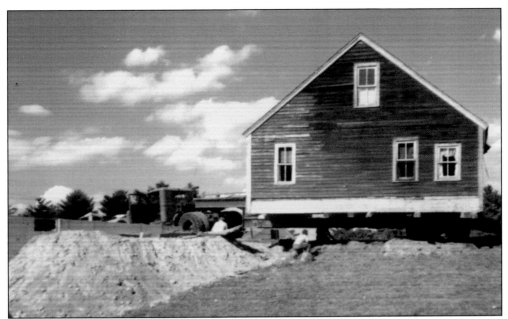

The first Methodist parsonage in New England is being moved onto its new foundation on Sandy Beach Road. It was moved a third of a mile west to its present location next to Crystal Lake School. Harold and Fred Limberger's truck is seen moving the structure into place. Built in 1795, it was last occupied by Lena Cady Webster, who lived there for more than 50 years.

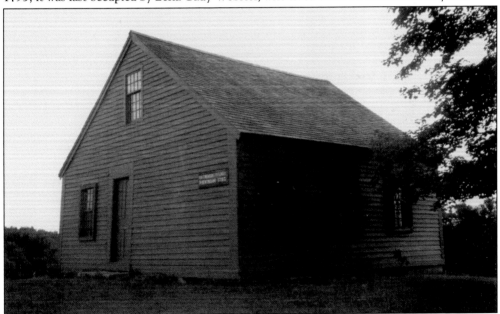

The Crystal Lake parsonage was dedicated as United Methodist historic site No. 331 on October 21, 1995. The exterior of the building has been renovated, and the Crystal Lake Historical Society hopes to restore the interior and open it as a museum. The original American chestnut clapboards were removed and replaced, but the chestnut beams remain. The restoration committee plans to re-create a fireplace and chimney appropriate for the late-18th-century parsonage.

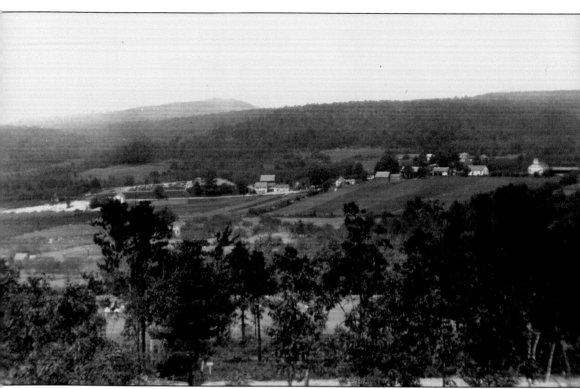

This early-20th-century view shows an unpaved White Road in the foreground. Note the small white street sign. The little village was now called Crystal Lake, after its name was changed from Square Pond in 1889. In the center of the photograph are, from left to right, a sand bank, the cemetery now called Crystal Lake Center Cemetery, and the large white building once used as the Square Pond Hotel. On the far right, the two white buildings are the Advent church (left) and the Methodist church with its bell tower and attached horse sheds. The cemetery was established when the Square Pond Burying Ground Association met on April 6, 1861, with the intent to "procure suitable ground near Square Pond in the town of Ellington and to prepare the same for a burying ground." The three-story Square Pond Hotel served not only as a hotel, but a post office and a tavern, and it is marked on the 1857 map of Tolland County as the Henry C. Aborn store. It was demolished in 1975.

Three

HOTELS AND
ROADSIDE CABINS

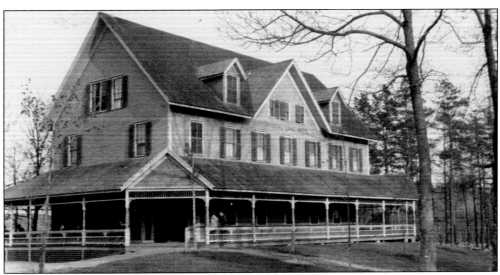

William Bowler and Joseph Coogan purchased Dimmick's Grove on the west shore of the lake and built the Crystal Lake Hotel, which formally opened on July 4, 1894. Coogan died in 1895 and Bowler took charge of the hotel. It was located just south of the present State of Connecticut public boat launch. The hotel was three-and-one-half stories high on the lake side. The front of the hotel with its spacious verandas, pictured, faced the trolley line that began service in 1908. The trolley passed Snipsic Lake on the way, and both lakes were then easily accessible from Rockville. A 1908 newspaper article promoting the "pretty lakes on the trolley line" said that there was a trolley station only 50 feet from the hotel. The promise of shore dinners and an 85-foot-long bowling alley were other enticements. There were 23 guest rooms on the second floor and attic, and a large dining hall on the main floor. The basement tavern, with its own entrance, housed pool and billiard tables.

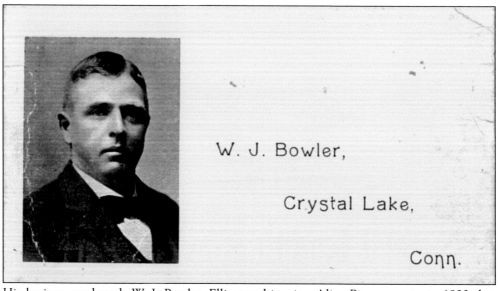

His business card reads W. J. Bowler. Ellington historian Alice Pinney wrote in 1930 that William Bowler was the first to have a vision of the business potential of the lake when he built the Crystal Lake Hotel on land known as Dimmick's Grove on the west shore. By the time he leased the property to Louis Koelsch around 1914, the resort community had become a "miniature Coney Island," according to Pinney.

William Bowler, proprietor, advertised rooms in the Crystal Lake Hotel by the day or week, and his advertisements promised "good boating, fishing, hunting and bathing." Fred Einsiedel of Rockville was in charge of the hotel register in May 1919 as guests from Connecticut, Massachusetts, and New York signed and registered for rooms.

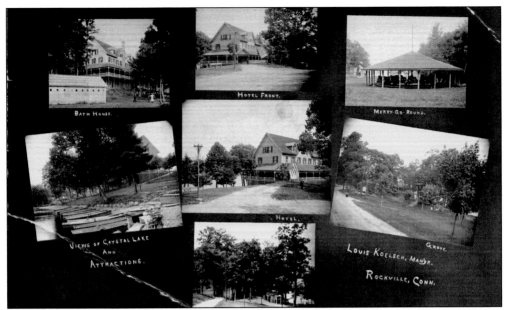

This 1914 postcard includes views of several of the attractions on the Crystal Lake property that Louis Koelsch leased from William Bowler. These included a dance pavilion, bathhouses, bowling alley, candy kitchen, merry-go-round, boats, steamer, bar, pool tables, and icehouse. After Koelsch took over the management of the hotel, he bought new electric musical equipment for the dance hall and launched a fleet of steel boats.

Little Roy Wendell Jr., whose family owned tourist cottages and cabins nearby, stands on the beach of the Crystal Lake Hotel in August 1927. Guests would have had good views of the lake from the rooms and verandas on the hotel's lake side. Towels and bathing suits hang on a clothesline under the veranda to dry.

Roy Wendell Jr. and his sister Marilyn are pictured in front of the burned remains of the Crystal Lake Hotel, which was gutted by fire on June 27, 1935, as it was being readied for the summer season. The Crystal Lake Fire Company, which was less than a year old, was the first to answer the alarm. A private home built on the foundation remains on the site today.

Ellington, Conn., *May 1* 189*1*

M*r* *Franklin Newell*

Your Taxes in Ellington on List of 1889 are :

Town Tax,	-	-	$.16.02
Commutation Tax,	-	-	2.08
Interest.	-	-	88
Total,	-	-	$ 19.20

Received Payment,

W C Bahr Collector.

Franklin and Ella Slater Newell lived on Newell Hill Road. Franklin was a farmer and a teamster who worked on town roads. Ella earned money selling eggs, sewing, mending, baking, and picking and selling berries. Her diaries reveal that they also boarded guests. One such entry, on December 9, 1894, reads, "Teacher, Miss Eastwood, stayed all night." The Newells paid $19.20 in town taxes in 1891, according to this receipt.

Entries in Franklin's and Ella Slater Newell's 1890s diaries contain many references to harvesting alder and chestnut wood, which Franklin took to the Hazard Powder Company in Enfield. Alder charcoal made high-quality gunpowder. Although the gunpowder plant, pictured from across the dam on the Scantic River, seems aptly named, it was named for Augustus Hazard, who organized the company in 1843. (Courtesy of the Connecticut Historical Society, Hartford.)

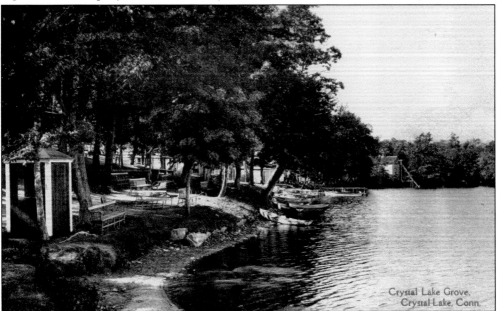

Ella Slater Newell mentions frequent visits to this grove at the Crystal Lake Hotel in her diary entries in July 1894. The icehouse can be seen on the shore beyond the boats. Lake ice was harvested in the winter and stored for summer use. The icehouse was donated by William Bowler to the Crystal Lake Fire Department, which moved it and remodeled it into a fire station.

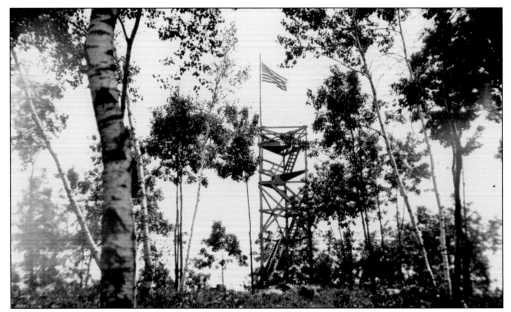

The Soapstone Mountain fire tower was atop the 1,075-foot mountain in Shenipsit State Forest on the Ellington-Somers town line. It was from this tower in May 1934 that a spotter saw a fire at the former Franklin Newell homestead on Newell Hill Road to the west of Crystal Lake. Although several fire trucks responded to the alarm, the eight-room house, built about 1780, burned to the ground.

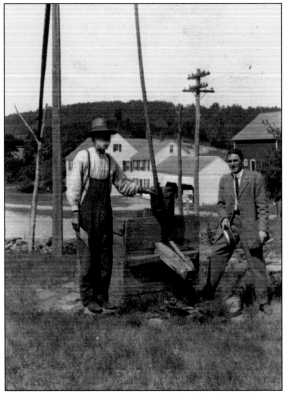

The Square Pond Hotel in this c. 1920 photograph is behind Sterry Taft (left) and a newspaper reporter, who were standing by a well at the corner of South Road and Sandy Beach Road. Chrystal Skinner Montgomery remembers drawing pails of water from the well when visiting the Aborn farm. The old hotel was purchased by Earl Rich. He and his wife, Agnes Willis, opened the Triangle Grocery in the building in 1949.

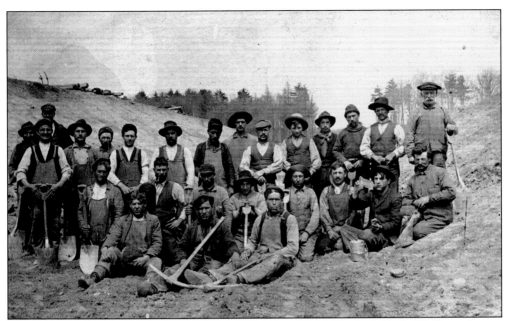

This photograph was marked "Mr. Pitter's 'gang' of men that worked on the trolley, taken in the 'cut' in Mrs. Martin's lot." Martin's Crossing was on the Tolland–Ellington line along the present Route 30. The workers pose in May 1907, probably while grading the trolley line that connected Rockville to Stafford Springs when completed in 1908. Italian laborers worked on the line and lived in huts constructed nearby.

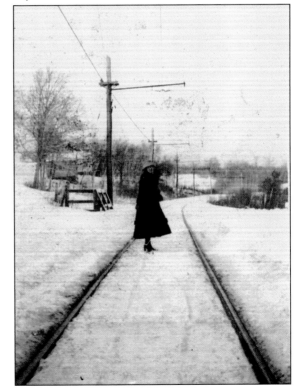

Martha Wendell stands on the interurban trolley line near the Stafford-Ellington town line in January 1923. The track ran along the west shore of Crystal Lake until it was torn up in May 1928. William Bowler, owner of the Crystal Lake Hotel, was a member of the special trolley committee that worked to assure that the lake would be easily accessible until the highway was completed.

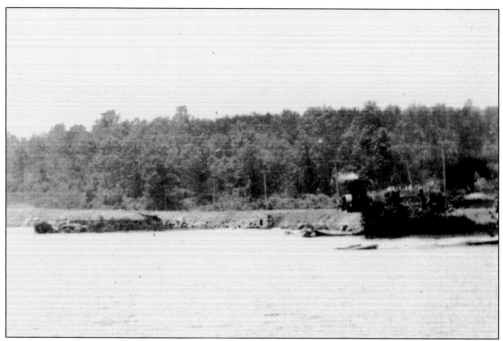

This steam tractor grades the new road at the north end of the lake on the Stafford-Ellington town line. Work was almost complete when this photograph was taken in July 1928 by a warden of the State Board of Fisheries and Game. The new road improved access to the hotel, cottages, and the new Sandy Beach Ballroom. The Crystal Lake Cemetery in Stafford can be seen to the right of the tractor.

In the 1930s, Crystal Lake was the destination for many Long Islanders, according to Roy Wendell Jr., whose family owned guest cottages and cabins. There were no bridges, so vacationers took the ferry to Westchester. From there they would travel by automobile, stopping along the way for fuel, food, and restrooms during the seven-hour trip. This car is pictured passing the Wendell cottages on Route 15, completed in 1928.

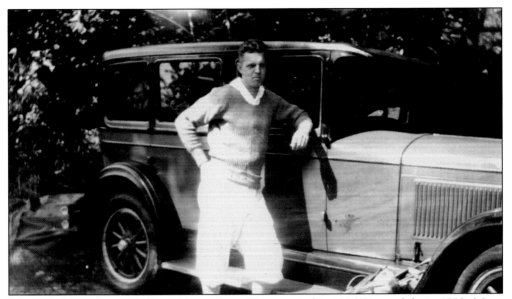

Roy Wendell Sr. is ready for a ride to the golf course in his 1926 Hupmobile in 1929. Many couples met and fell in love at Crystal Lake. Roy's son, Roy Jr., met his wife Jean at a dance at the lake when she was vacationing from New York at Wendell's Woodhaven cottage in July 1948. They married the next summer.

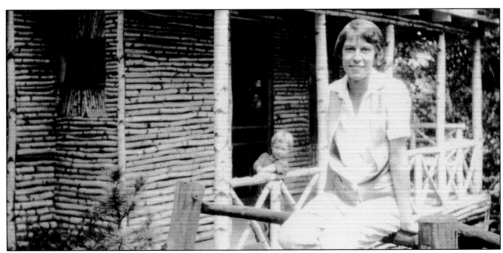

Roy Wendell Sr.'s wife, Irene Cayea, and their son Roy Jr. pose in front of the Birch Cabin in August 1927. Note the unique birch siding. Martha Wendell, Roy's mother, named the cottages after places that had family connections. The Wadena was named after the USS *Wadena*, on which her son Edgar served in World War I. The Wadena's fireplace still stands on Roy Jr.'s son Kenneth's property on Wendell Road.

Roadside tourist cabins were popular with auto-trippers, who could afford these inexpensive accommodations even during the Depression era of the 1930s. Low gas prices made vacations even more affordable. A 1945 Crystal Lake postcard shows a sign advertising gas at six gallons for $1. The two one-room cabins in the foreground, the Petunia and the Marigold, stood near the state road in front of Martha Wendell's Lovely Lucerne cottage.

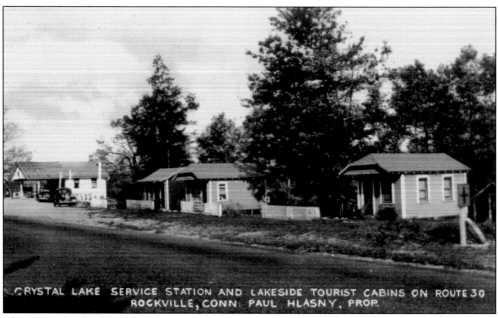

The Crystal Lake Service Station and tourist cabins were owned and operated by Paul and Etty Hlasny for 25 years. The Hlasnys promised "Never a dull moment at the Lakeside Tourist Cabins." A Rockville address was used because mail was delivered by the Rockville Post Office from 1908 until 1975. Route 15 had been renumbered Route 30 by the time this postcard was printed.

Four

RAU'S PAVILION
AND THE MARKERTS

This photograph of Rau's Pavilion on the northwest shore was taken shortly after it was built by Conrad Rau in 1915 on four lots that he bought from William Bowler. The dance pavilion, added later, attracted people from all over the eastern part of Connecticut. By 1930, crowds of 1,000 were not uncommon, as people seeking some relief from the hard times of the Great Depression found that a drive to the lake to swim and dance was an affordable treat. A restaurant, canoe lockers, and a dock were added. Older Crystal Lake residents remember the building as Rau's. After the building burned to the ground in February 1940, it was rebuilt. The property then changed hands several times. Younger folks remember it as Jack's Pavilion, the Clearwater Beach Club, or the Crystal Lake Beach and Boat Club. It has now been converted into a private home.

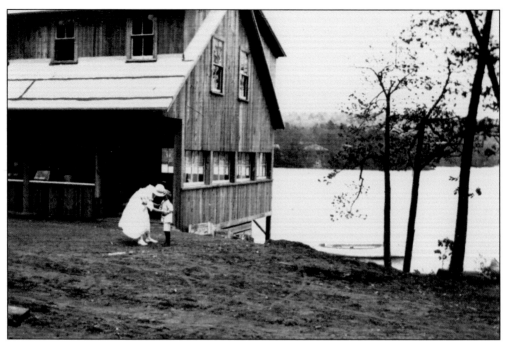

Conrad Rau's wife, Emma Markert Rau, talks to her son Clemens next to the new pavilion around 1915. The Raus lived upstairs. This view of the building on West Shore Road looks across the lake to the northeast shore. Emma's mother, Sophie Liebe Markert's summer cottage, called Suits-Us, was on the east shore of the lake.

Clemens Rau is pictured here at age four around 1915 at his father's pavilion on the west shore. As an adult, Clemens took over management from his father, Conrad. Clemens was appointed secretary/treasurer at the first meeting of the newly organized Crystal Lake Yacht Club in July 1937. When the pavilion burned in the winter of 1940, all the yacht club records were destroyed.

This photograph of Rau's original pavilion was taken when the leaves were off the trees. A few canoes are on the shore. Later boat lockers were built so that cottage owners could store their canoes, and visitors could rent canoes for the day. Boating and swimming were popular activities. The Rockville–Stafford interurban trolley brought people to the lake.

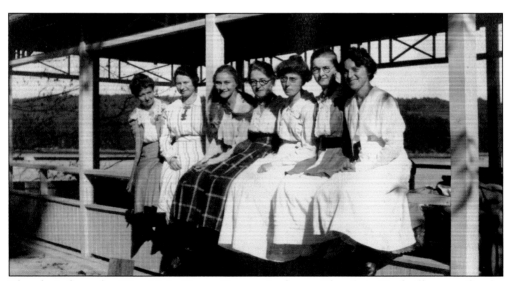

The choir from the West Main Street German Lutheran Church in Rockville poses for the photographer at its choir picnic, which was held at Rau's Pavilion. Cora Markert is third from the right. Crystal Lake was a very popular place for churches, schools, fraternal organizations, and social clubs from Rockville to hold their picnics.

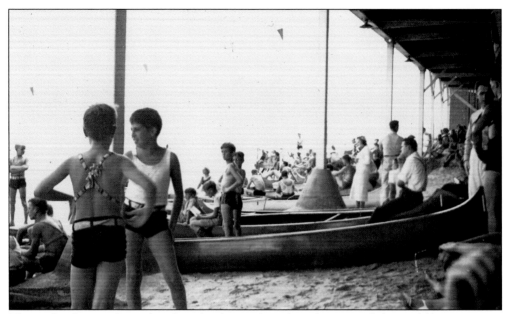

This undated view of Rau's beach under the pavilion shows how crowded it could be on a sunny day. Canoes for rent were stored in lockers, two rows high. A dance hall was added in the 1930s, and name bands performed on Saturday nights. Rau's advertised, "Where discriminating people meet and enjoy dancing, swimming, canoeing." Many couples met and fell in love at dances at Crystal Lake.

Emma Markert Rau's family lived on the east shore. Her mother, Sophie Liebe Markert, is pictured on the veranda of her cottage, Suits-Us. It was one of several that lined the wooded east shore of the lake. Bamboo shades are lowered to provide shade from the bright afternoon sun. Boats are ready at the dock for a trip on the lake.

In this *c*. 1916 photograph are, from left to right, Lillian Markert, her mother Sophie, and her sister Cora Markert. They are dressed in the height of fashion, with channel-stitched seams and covered button detail on their long, flared skirts. Lillian's look is completed by a long bead necklace, and Cora's with a chatelaine perfume bottle pendant.

From left to right are Cora and Leroy Markert and their mother Sophie. Leroy graduated from West District Grammar School in Rockville in 1915, a year before this photograph was taken. He was elected treasurer of the class of 1919 at Rockville High School and later became a councilman in the city. Even after he moved to Massachusetts, he returned to Crystal Lake to race in the yacht club races.

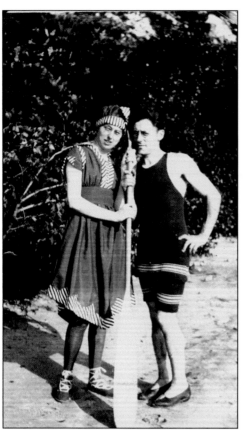

Cora Markert and Paul Menge are pictured on Baker's beach around 1916. Menge's bathing costume includes shoes that look like leather flats. He served in World War I, and the couple married in June 1919, after the war ended. They lived in the Rockville area all their lives. Their daughter, Adelaide Menge Campbell, still lives at the lake.

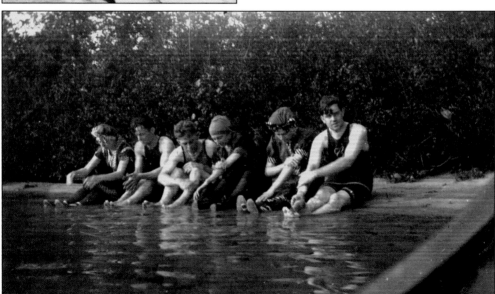

Leslie Cooley (right) faces the camera at a bathing party with his friends at Baker's beach. He married Lillian, one of the Markert sisters. Carefree bathing and canoeing parties must have seemed like idyllic memories when Crystal Lake men went off to Europe to fight in World War I in April 1917.

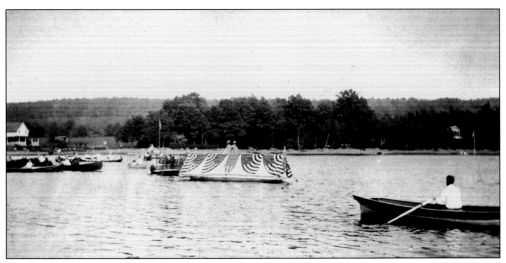

The first annual canoe carnival was held at Crystal Lake in 1919. The first two carnivals attracted over 3,000 spectators from all over the state. Service on the Rockville–Stafford trolley line was inadequate for the crowds of people who attended, so plans were made to add additional trolleys for the third carnival in 1921, which was organized by Conrad Rau.

This view of a canoe carnival is from the northwest end of the lake, looking east toward Syndicate Point. Over 150 canoes took part in the water events and canoe parade in 1921. Races were held for different size canoes, and separate races were organized for men and for women. Paddles, back rests, cushions, and blankets were awarded as prizes.

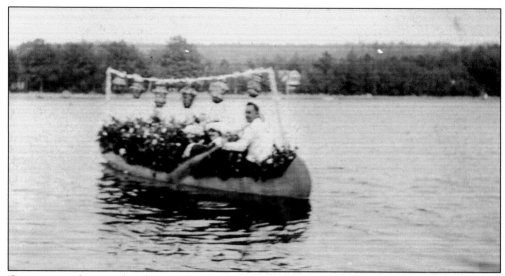

Canoes were decorated and entered in competition. This canoe has been decorated with flowers and hanging lanterns by an unidentified entrant. Prizes were awarded for the prettiest canoe, the funniest canoe, and the best decorated. Diving contests and tub races were other carnival activities. Contestants in tub races climbed into wash tubs and paddled with their hands to the finish line.

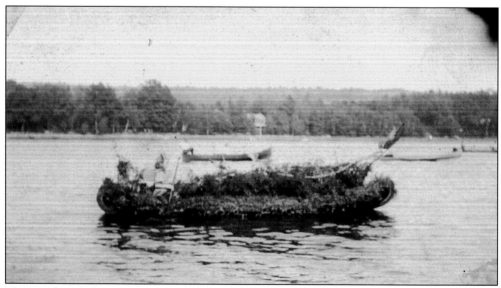

This unidentified canoeist is almost hidden by all the greenery used to decorate the canoe. Carnivals were held annually for several years at Crystal Lake before being discontinued. When a carnival was again held in 1937, the first in 10 years, it was a smaller event than earlier ones. Only 16 canoes and 5 boats were in the parade. About 500 people attended, and it was considered a success.

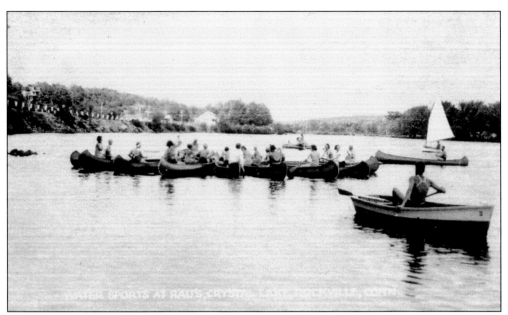

Canoes gather for the start of the races on the lake near Route 15, which can be seen on the shore on the left of the photograph. Four lifeguards from the New London Corps gave a diving exhibition at the 1937 carnival, and a swimming coach from the Coast Guard Academy gave a clown diving exhibition. The Crystal Lake Fire Department demonstrated its portable pump on a raft.

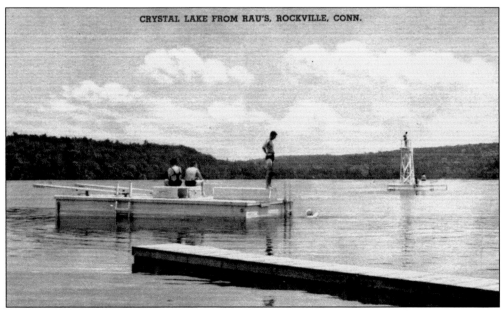

This is a familiar scene for old-timers who went to Rau's in the 1940s. The dock, the raft, and the low and high diving boards provided plenty of diversion on a sunny summer afternoon. The high diving tower served as the location for the starter for Crystal Lake Yacht Club sailboat races.

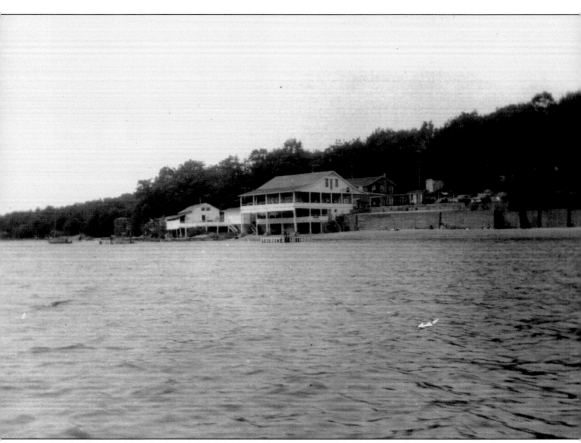

In the late 1940s, the beach club became known as Jack's Pavilion. It was owned and operated by John Yedziniak and his wife. Yedziniak sold the club to retired New York policeman James Conway in 1956, the year that this photograph was taken. The sign on the north side of the pavilion still reads "Jack's." Conway named it the Clearwater Beach Club and turned it into a private club in 1960. Singer Gene Pitney, a Rockville native who was inducted into the Rock and Roll Hall of Fame in 2002, bought the Clearwater Beach Club in 1976 with Philip Volz. Pitney had worked in the snack bar when he was a young man. The new owners operated the property as a private beach club named the Crystal Lake Beach and Boat Club.

Five

WINTER ON THE LAKE

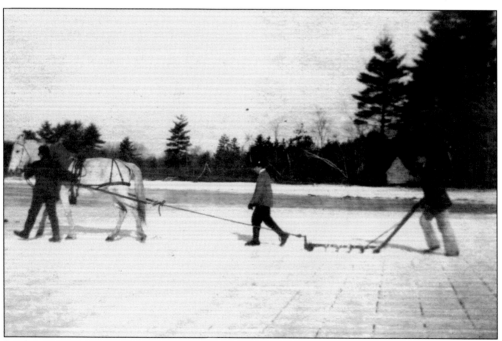

Ice harvesting was an important industry on Crystal Lake before the age of refrigeration. Ice had to be at least 12 inches thick before cutting. In this photograph, a horse is pulling a marker, which cuts groves in the ice to mark oblong shapes that will be cut into cakes. First, the surface of the lake ice would have been scraped clean of snow and porous ice until a smooth, clear surface was created. The man at the right is guiding the marker, and his weight on the handle ensured that the teeth of the marker would cut into the surface. Next, a plow cut the ice into cakes along the groove lines, and the cakes were broken out with saws, forks, hooks, and spades. Cakes were brought on a sled to an icehouse, where they were hauled up an inclined scaffold by rope and pulley through a door at the top of the house. The ice was stored for summer, when it was delivered to customers for their iceboxes.

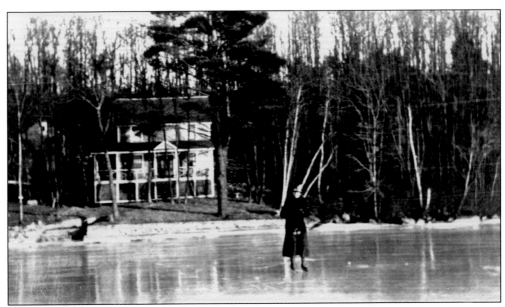

Cora Markert skates in front of the cottage named the Laurel on the east shore of Crystal Lake around 1918. Shore dinners were served at the Laurel during the summer. Cora's skating costume was fashionable for the time. She wore a long skirt and a warm jacket with fur trim, and she carried a fur muff to keep her hands warm. Her ice skates were fastened with leather straps.

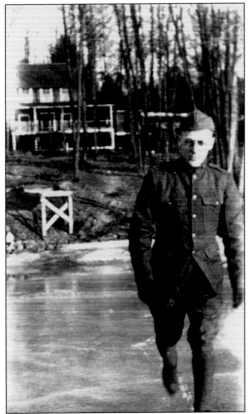

Paul Menge is wearing his World War I uniform as he skates in front of the cottage named Deer Rest in the winter of 1918. After the war, Menge became the second post commander of the new Rockville American Legion post. He worked for 40 years for the Hockanum Mills Company and the M. T. Stevens and Sons Company, which bought the Hockanum Company in 1934.

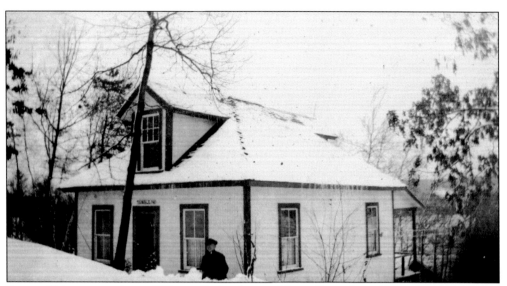

Everett Skinner, grandson of Warren Richardson and Luna Dimock, and his wife, Ann, lived in the Tumble Inn cottage, pictured here in 1923. The Skinners brought their newborn daughter Chrystal, who was named for Crystal Lake, home to the cottage in September 1927. She was told that there was a crack in the wall, and snow sifted in onto her crib.

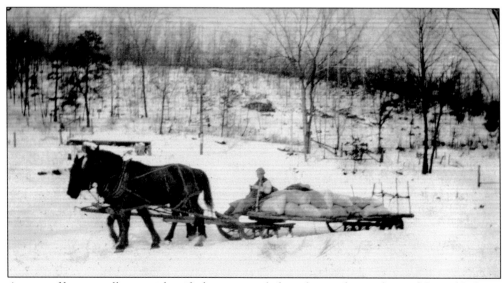

A team of horses pulls an unidentified man on a sled on the northwest shore of Crystal Lake in January 1923. This is the type of sled used to carry blocks of harvested ice to icehouses on the shore, but the contents of the sacks on this sled are unknown.

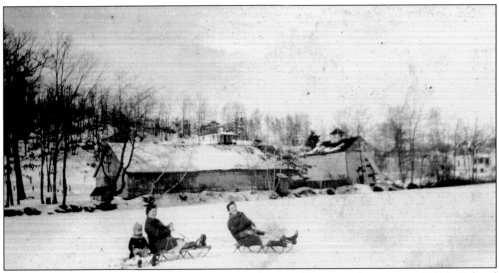

Three unidentified people on sleds enjoy themselves on the ice in the winter of 1923. Behind them are two buildings on the property of the Crystal Lake Hotel. The conveyor that carried the ice up to the door at the top of the icehouse can be seen on the right. The icehouse was moved and became part of the Crystal Lake Fire Department.

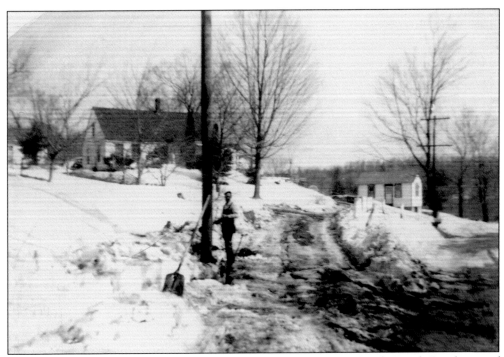

Fred Truempy shovels snow in front of his home around 1935 on Sandy Beach Road, east of Minor Hill Road, which was formerly known as San Juan Hill Road. Truempy was born in Switzerland in 1888 and moved to the United States in 1912. The house was once the home of Ellington farmer and sawmill owner Daniel Curtis, and it is no longer standing.

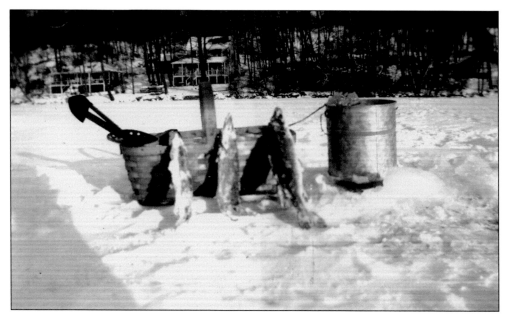

An account of ice-fishing at Crystal Lake in the 1938 Federal Writers' Project American Guide Series says that holes about a foot in diameter were cut in the ice, and a reservoir for the caught fish was chiseled out. The fish in this c. 1940 photograph appear to have been flash-frozen after being caught off the east shore of the lake.

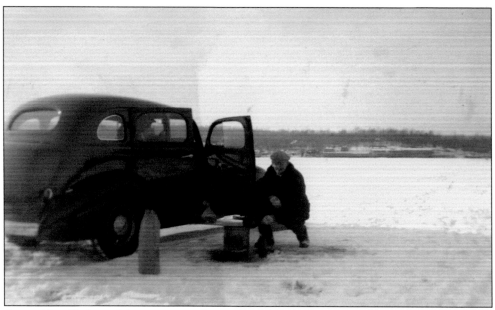

An unidentified ice-fisherman crouches near a late-1930s model Chevrolet sedan, while a companion sits in the driver's seat sipping a cup of coffee to stay warm. Rau's Pavilion is visible across the lake. Ice-fishing at Crystal Lake in 1938 was reported to be excellent by the Federal Writers' Project writer. Perch and pickerel were caught using shiners, small silvery fish, for bait.

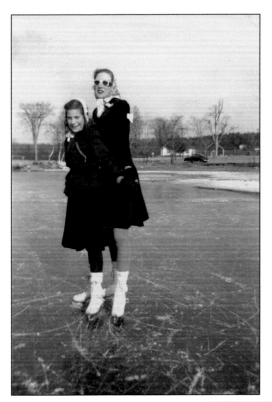

Gretchen Baker (left) and Harriet King stop and pose for a photographer while skating near the Stafford dam on the northernmost end of Crystal Lake. Harriet is wearing sunglasses on this bright winter day. The ice is clear, and the lack of snow on the shore indicates that it was a cold, dry winter.

Harriet (left) and Margaret King, seated on the bumper of a 1941 Packard Special, take a break from figure skating near their cottage, called Four Kings, on the east shore. Most cottages had names, and the Kings' cottage was named after the family of four: Everett, Hattie, and their two daughters. Harriet married Robert Markert who lived in the cottage called Deer Rest. Margaret still lives at Crystal Lake.

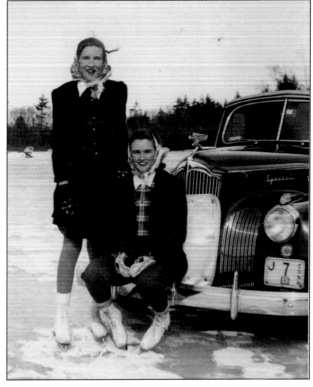

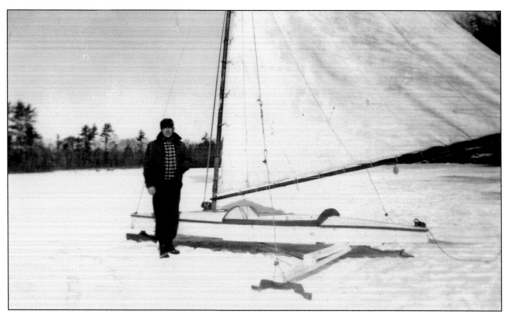

For those who loved sailing, like George Grennan, the sport was not limited to summer sailing on soft water, but was also enjoyed on hard water, as ice is called by iceboating enthusiasts. George was the first commodore of the Crystal Lake Yacht Club in 1937, but winter found him gliding across the frozen lake on his iceboat, seen in this January 1940 photograph.

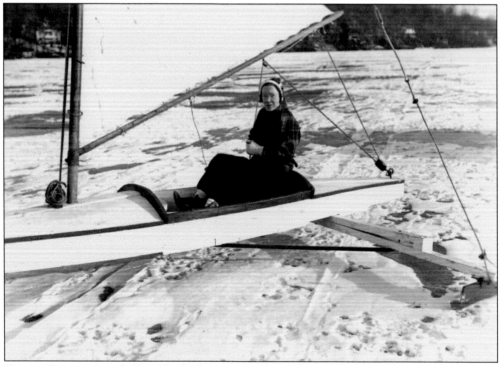

George Grennan's wife Dorothy had a turn in the iceboat. One of its runners can be seen attached to the boat's frame on the right of this photograph. Smooth, clear ice is preferred for a perfect sail, but on this day there was a coating of snow on the lake.

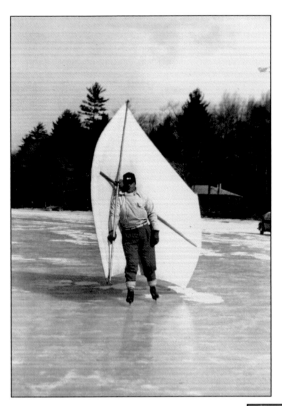

George Grennan is pictured on skates with a lightweight hand-held sail, which he used to propel himself across the icy lake. A spar supported the sail, which he held leeward, that is, facing the direction the wind was blowing. He held the control stick on the windward side with his right hand.

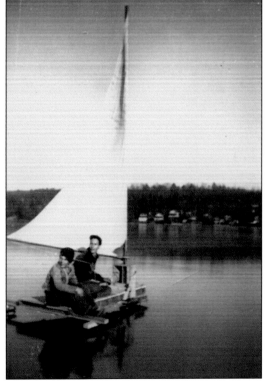

Phil Tolisano (right) and a friend try out an iceboat that Phil made himself in the early 1940s. The boat was on the west shore near Phil's father's Sandy Beach business, Red's Tavern. Winter sports, especially ice-fishing, are still popular at Crystal Lake. The Connecticut Department of Environmental Protection reported catches of a 24-inch brown trout, an Atlantic salmon, and largemouth bass in March 2008.

Six

WEST SHORE
AND SURDEL'S

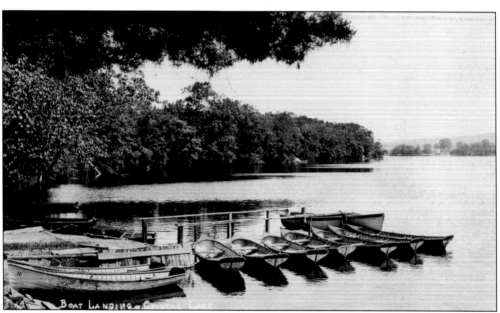

This 1920 postcard of the boat landing at Crystal Lake shows a view of the west shore looking north toward the Stafford end of the lake. The heavily wooded shore hides the many summer cottages that had been built along the lakefront. The state road had not yet been built, so people still traveled to the lake by trolley. In a 1930 newspaper article, Alice E. Pinney wrote that she had discerned the secret of the lake's success. "It is not a water supply, nor does it furnish water power for any industry, not even a saw mill. It is a little pleasure ground at the top of the world for the people."

From left to right are Caroline Zimmerman Kuhnly, John Kuhnly, Hazel Kuhnly, Harriet Nutland Kuhnly, William Kuhnly, and Lucille Kuhnly around 1922 at their cottage on Private Grounds Road. In 1917, when Hazel was five years old, the Kuhnly family of Rockville was headed to Savin Rock in West Haven for a vacation. On the way, they learned of a polio epidemic in the area, so they turned around and headed home, where Grandpa John Kuhnly rented a cottage at Crystal Lake. The next year, he bought the cottage, and 90 years later it is still in the family. John Kuhnly went into the plumbing business in Rockville in 1880 with his brother Edward, and after Edward's death, John became the secretary-treasurer of the Kuhnly Plumbing and Heating Company when it was formed in 1905. The company installed furnaces in many of the mansions of the mill owners in Rockville. William Kuhnly was the superintendent of the Rockville plant of the Horton Manufacturing Company, which made Kingfisher fishing line.

In the photograph of John Kuhnly's cottage Edgewood, above, taken before the Hurricane of 1938, there is a large tree to the left of the cottage and a white birch in front of it. The winds destroyed the two trees, which are missing in the photograph below, taken after the storm. The tree on the left fell on the cottage, leaving the frame slightly crooked. When new first-floor windows were installed, they were put in perpendicular to the ground, but the top of the window is closer to the edge of the house than the bottom. The cottages had lampposts like the one pictured here. Before electricity was installed, they were lit by oil, and the shore twinkled on summer nights with the lights of all the lampposts.

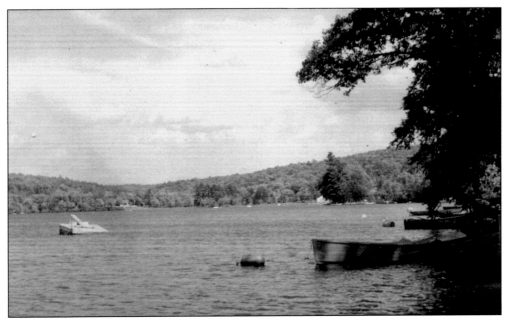

There were three cottages on the west shore owned by the Kuhnlys. This view is from the Private Grounds Road cottages toward Sandy Beach. Hazel Kuhnly recalled that every Sunday the family got together, and "it was not unusual for us to have 25 or 50 people for Sunday night supper at the lake. There were always a few pinochle games played, since all the Kuhnlys were addicted to pinochle."

Gordon Brigham's horse drinks from the lake near the Brigham cottage on Private Grounds Road on the west shore around 1940. The water level was low, making it possible to walk along the shore toward the boat launch. Gordon, his brother Rodney, and their father George took over the George W. Hill Lumber Company on Vernon Avenue in Rockville in 1963.

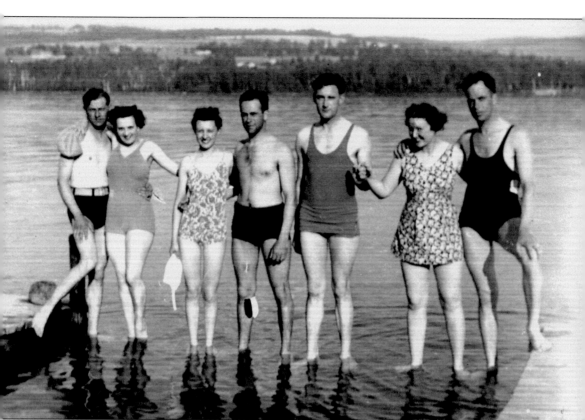

These young people are enjoying the halcyon days before World War II. World events shook the tranquility of Crystal Lake on December 7, 1941, when Pearl Harbor was attacked. This photograph was taken by Alice Peterson Williams on the west shore looking toward the Minor farm on the hill on the east shore. The young people from Rockville are, from left to right, Joseph Kadelski, Cora Chagnon Kadelski, Margaret Kent Kloter, Noel Kloter, Edward Williams, Dorothy Stevenson Kloter, and Winfred Kloter. Noel Kloter and Joseph Kadelski enlisted in the U.S. Army Air Corps. Three brothers in the Willis family of Crystal Lake went into the service too, and their sister Delphine Willis Tomasek recalls that the sisters kept the mailman busy with all the letters they wrote.

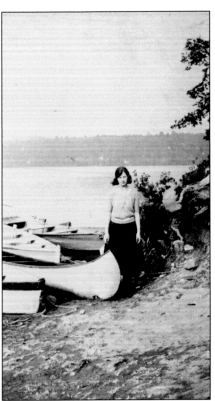

Corinne Tilden is ready to go canoeing around 1922. Tilden was a member of the first graduating class at the Yale University School of Nursing and became the medical director for the pasta manufacturer C. F. Mueller Company. Born in Ellington, Tilden was a descendant of New York governor Samuel Tilden. She returned to Ellington after retirement and moved into the former Henry C. Aborn and Son store on Maple Street in 1978.

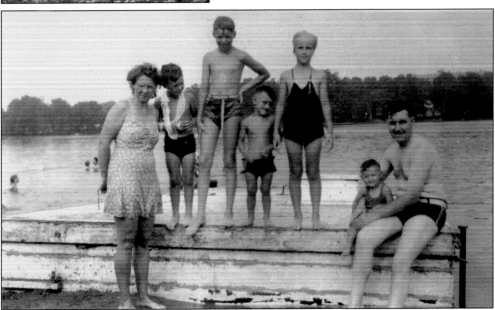

Posing for photographer Geraldine Fahy on the dock of the Casello cottage on the west shore around 1950 are, from left to right, Ruth Casello, Bernard Fahy Jr., Joseph Casello Jr., Timothy, Mary, Gerard, and Bernard Fahy Sr. As well as visiting the lake, the Fahys of Rockville often drove out to Crystal Springs just south of the lake in Tolland to enjoy a picnic supper under the cool pines.

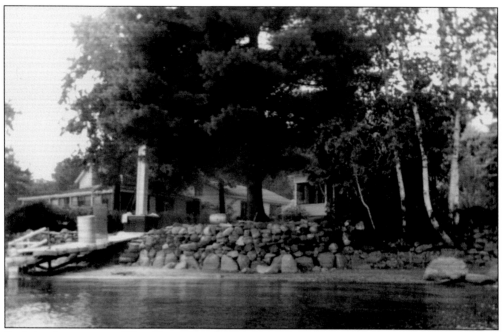

Paul Arzt's cottage on West Shore Road had a dock that was raised with the help of the white pole seen on the left. A dock is a perfect place for fishing and relaxing in the summer, but taking a heavy dock in for the winter is not easy. It is an annual ritual, as is putting it out in the spring after the ice has thawed.

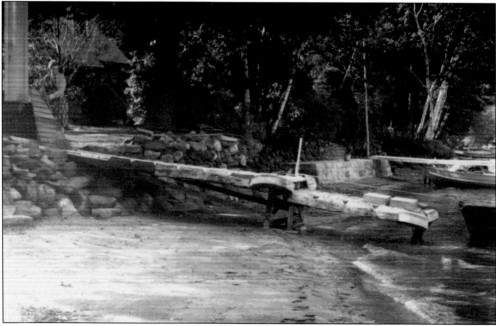

Marjorie Little Arzt stands near the head of the dock at her cottage in the 1960s. The lake was low, and there is a wide expanse of sandy shore. The land behind the Arzt cottage was the site of the old Crystal Ballroom, and is now the location of a subdivision of homes on Crystal Ball Court, named in tribute to the famous dance hall.

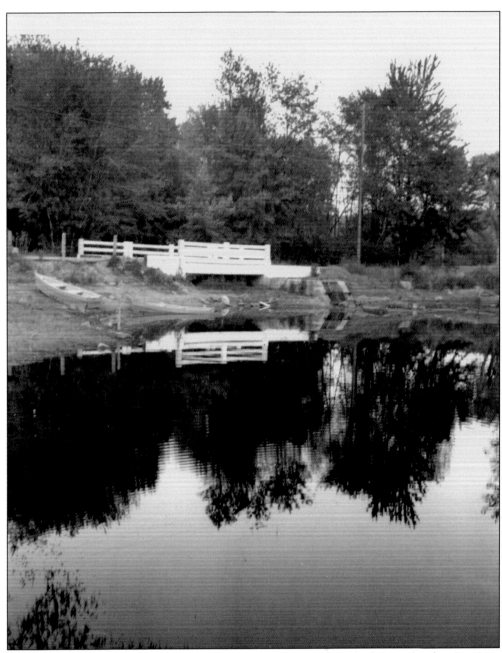

Conklin Road in Stafford passes over the dam on the north end of Crystal Lake. In 1830, George Dimmick of Stafford obtained leases from shoreline residents. He had holes drilled in rocks on the east and west shores to monitor the water level, and then built a stone dam at the north outlet. The present concrete dam replaced a road built in the 1840s to its south that is now submerged. Stafford textile mill agents took control of the flowage rights in the 1850s, and retained them until 1952 when Stafford Printers purchased the rights. Clement H. Royer of West Hartford then bought the rights from the printers. His plans to lower the water level of the lake and general concern for the lake led shoreline residents to form the Crystal Lake Association in the late 1980s.

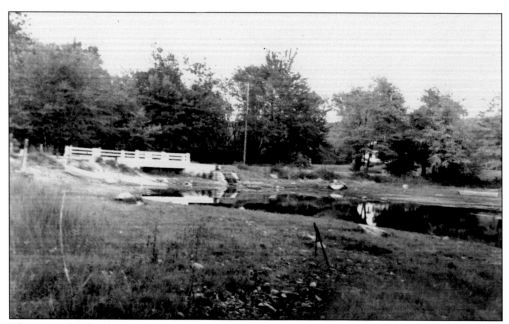

The Crystal Lake Association's purpose is, according to its Web site, "to preserve, protect and improve Crystal Lake and its surrounding area and promote the general welfare of the property, its owners and residents." Its members are concerned about water quality, invasive plant control, and dam issues. Over the years, the water level has been lowered many times by dam owners, as in this 1960s photograph.

This photograph was taken looking north at the Stafford end of the lake in the 1960s, with Route 30 on the left and the dam just visible at the northernmost point. This area and the northeastern shore were found to be the most heavily infested with the invasive plant variable-leaved milfoil in a 2007 survey. Measures are being taken to remove it after a demonstration suction harvesting project was conducted in 2006.

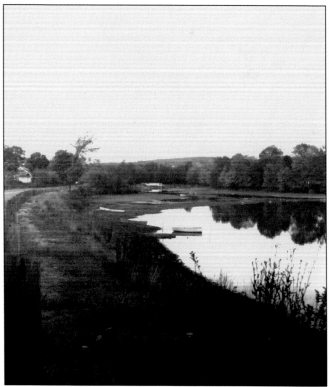

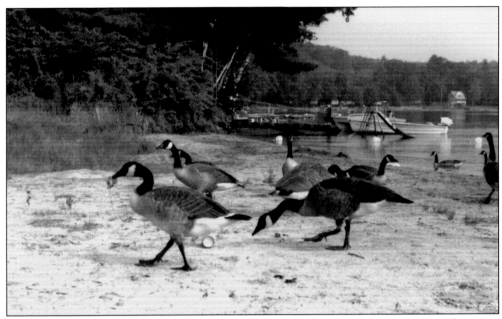

These migratory Canada geese were feeding on the west shore in the early 1960s. The goose population has been increasingly non-migratory, attracted by the lake's aquatic plants and lawn grass. Fishermen are also attracted to the lake in large numbers. Crystal Lake is stocked with large hatchery trout for anglers, and has been designated a trophy trout lake under the Connecticut Department of Environmental Protection Trout Management Program.

Paul Arzt cleans up the yard behind his cottage on West Shore Road. Part of the Crystal Ballroom can be seen to the left of the shed. The cottage is still in the Arzt family, and the shed is still standing today, but the ballroom is gone and is now the location of Crystal Ball Court.

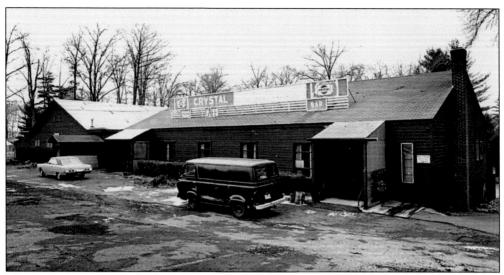

The Crystal Ballroom, the building on the left behind the bar, was razed in 1991, shortly after this photograph was taken. Built in 1946, it was the venue for entertainers like Duke Ellington, Gene Krupa, John Lee Hooker, Bobby Kay, Buddy Rich, Les and Larry Elgart, Lionel Hampton, and Ray Henry's, Gene Wisniewski's, and Al Soyka's polka bands. (Courtesy of the Journal Inquirer.)

This small house and concession stand, managed by Edwin Surdel, was popular with beachgoers in the summer, but it was Surdel's Crystal Ballroom that gained fame. A November 1956 beauty contest attracted 55 entries from Connecticut and Long Island. The grand prize winner, to be chosen from six finalists, would be named Miss Crystal Lake and receive a trip to New York, a gown, and $100.

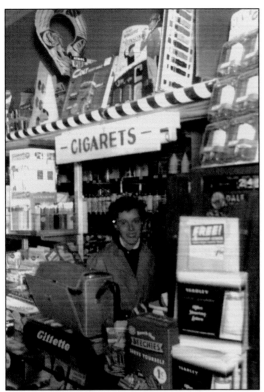

An unidentified clerk works behind the counter of Surdel's concession stand in the 1960s. It looks like one could find whatever was needed here, including cigarettes, Gillette razors, Ronson pocket lighters, and Beech-Nut Beechies, a peppermint-candy coated gum. Purchases were rung up on the vintage cash register to her right, where the total, 24¢, was probably for a pack of cigarettes.

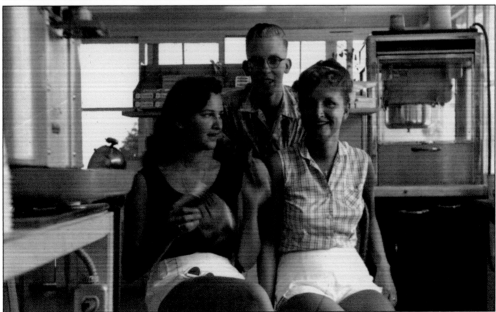

Windsor's Ray Henry Mocarski and his Ray Henry Polka Orchestra recorded for the Dana label and appeared at the Crystal Ballroom in the 1940s and 1950s. Fans called for their popular "Blonde Bombshell Polka" and their theme song, the "Golden Gate Polka." From left to right are Mocarski's wife Gloria, Frederick Arz, and Mocarski's sister-in-law, Mary, in Surdel's concession stand.

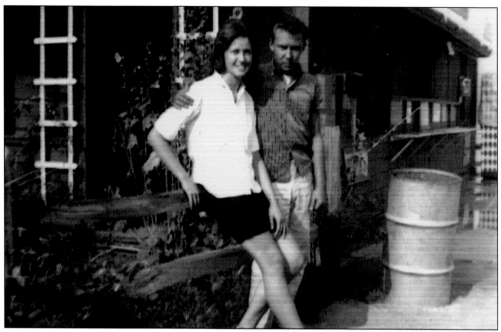

Pauline Soukup (left) and Daniel Surdel stand outside of the original wooden snack bar in the summer of 1961. Surdel's father, Edwin Surdel, owned the popular Crystal Ballroom and the beach and concession facilities on West Shore Road. In later years, the Pagani family of Manchester owned and operated the Crystal Lake Park Restaurant and Ballroom.

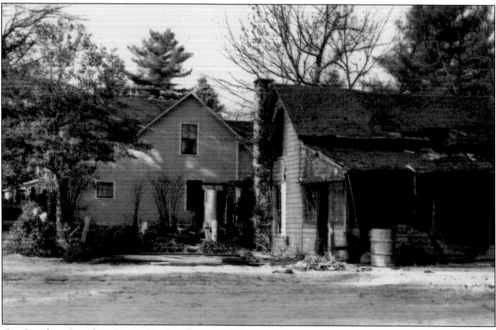

On Sunday, October 29, 1961, fire destroyed the combination concession stand and house. Fire Chief Joseph Willis of the Crystal Lake Fire Department reported that his company and three other companies fought the blaze in the building, which was at the rear of the Crystal Ballroom. The Arzt family cottage, seen behind the burned out building, was saved.

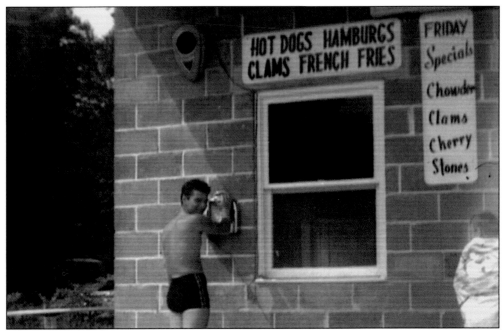

Paul Cassetta (left), a Brooklyn, New York, resident summering at the lake in 1962, and an unidentified boy stand outside of Surdel's new concession stand, which was built to replace the stand that had been destroyed by fire at the end of the previous summer season. Cassetta is playing the jukebox, which got a lot of use when teenagers were at the lake.

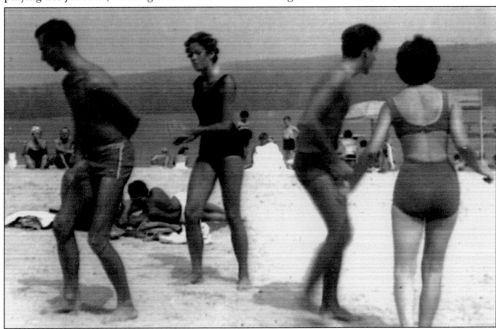

From left to right are Lawrence Boudreau, Pauline Soukup, Francis Genovesi, and Sharon ? dancing on the sand. Soukup recalls that they were probably dancing to the disc jockey's recording of the "Wah-Wahtusi" by the Orlons, which was a favorite of teenagers that summer of 1962, when the group's first national hit reached No. 2 on *Billboard*'s pop chart.

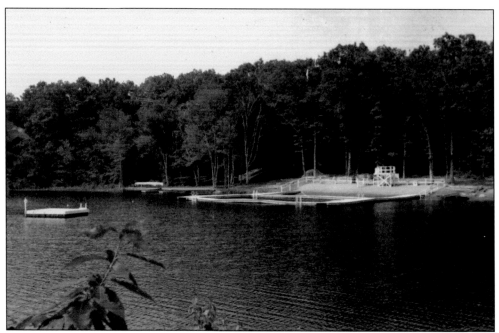

This photograph was taken from across the lake toward a private beach on the west shore that was developed in the location of Surdel's. When buses arrived at the day camp, this peaceful scene would be filled with happy children swimming to the raft, paddling in the canoes, and playing on the beach.

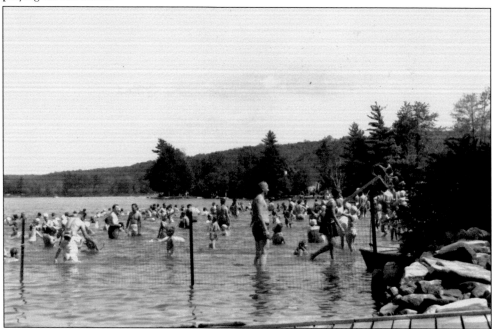

Families crowd the beach and shallow water at the private beach on the west shore next to the Arzt family cottage. Evergreens on the shore add to the quiet beauty of the spot. The shore is now lined with residential properties, and the only public lakefront is Sandy Beach, operated by the Town of Ellington.

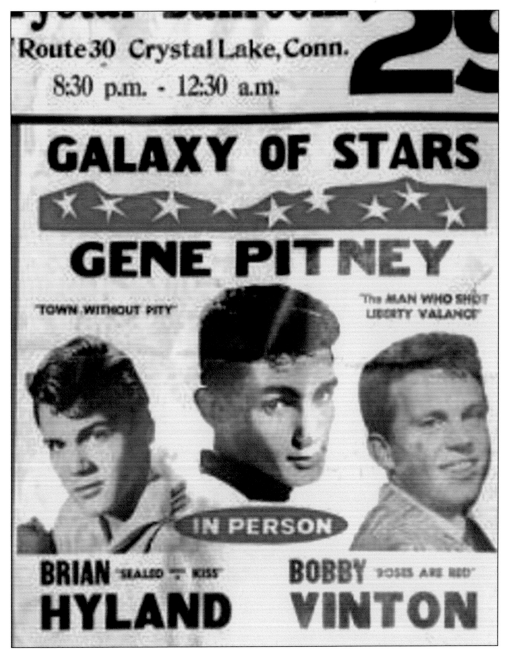

This poster advertises a concert at the Crystal Ballroom on July 29, 1962. Headliners Gene Pitney, the "Rockville Rocket," made the charts that year with "Town without Pity," Bobby Vinton with "Roses Are Red," and Bryan Hyland with "Sealed with a Kiss." Pitney, who grew up on Hammond Street in Rockville, was a 1958 graduate of Rockville High School. He signed a three-year $250,000 contract with the William Morris Agency in 1961, and in May 1962 he sang his hit, "Town without Pity," at the Academy Awards ceremony. A small-town man at heart, Pitney married his high school sweetheart, Lynne, and built a home nearby. Pitney's lake connection was reinforced when he and Philip Volz purchased the former Clearwater Beach Club in 1976 and established a private club, the Crystal Lake Beach and Boat Club.

Seven

WIND IN THE SAILS

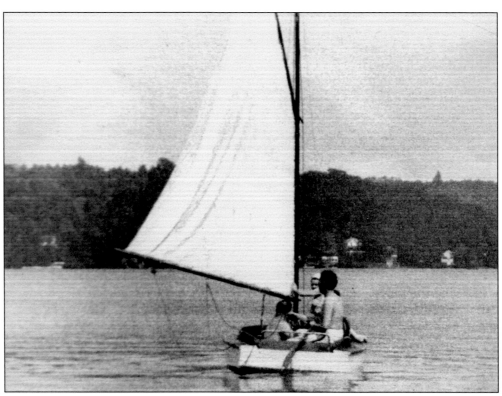

In the late 1930s, skippers on Crystal Lake began informal races by pacing their sailboats up and down the lake, picking out landmarks, and racing toward them. A new era of sailing began with John "Pop" Grennan's *Jean* and the formation of the Crystal Lake Yacht Club in 1937. The roots of the yacht club go back to when Grennan brought his homemade boat *Jean*, pictured here, down from his farm on Soapstone Mountain and launched it into the lake. *Jean* was a gaff-rigged craft whose bowsprit and broad beam made it easily recognized on the lake. George Grennan sailed the *Jean* and won the first trophy from the new yacht club in 1938.

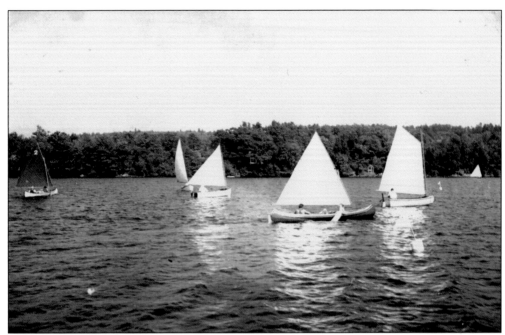

At the 25th anniversary picnic of the Crystal Lake Yacht Club, members reminisced about the early days of sailing on the lake, such as the time in 1910 when a man draped an old piece of canvas over a pine bough to create a sail for his rowboat. Parley Patten and Charles Wilson and others also converted rowboats and canoes, like the ones in this photograph.

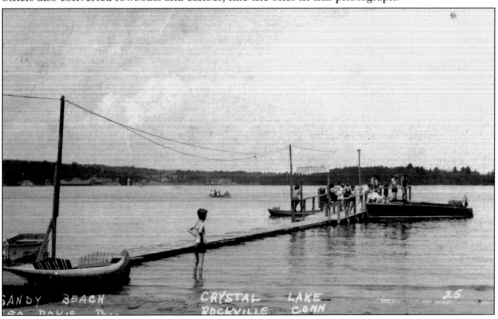

In the 1930s, at the same time that sailboat racing was becoming the up-and-coming activity at the north end of the lake, Sandy Beach at the southeast end was becoming very popular under the stewardship of George Bokis, who, after leasing the property for several years, purchased it from William Bowler in 1925. In this photograph, passengers are lining up for 25¢ rides on the Chris Craft.

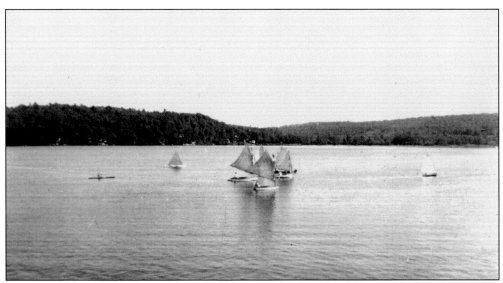

The first race of the Crystal Lake Yacht Club, which took place in August 1937, is pictured here. The races started at Rau's Pavilion. Charter members of the club were George Grennan, Everett King, Leroy Markert, Charles Moore, Parley Patten, Clemens Rau, and Edward Wilde. Rau donated the first trophy in honor of his mother, Emma Markert Rau. Grennan was the first commodore and served from 1937 to 1941.

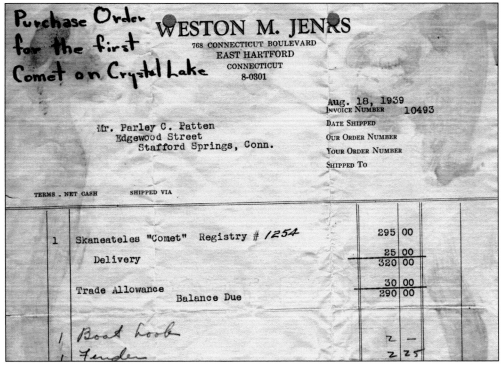

The receipt for the purchase of the first Comet to sail on Crystal Lake shows that it was purchased by Parley Patten of Stafford in August 1939. Comets were built by the Skaneateles Boat and Canoe Company. Patten's cottage on Syndicate Point became the starting point for the yacht club races by the 1950s. He was still racing Comets, the most popular type of boat on the lake.

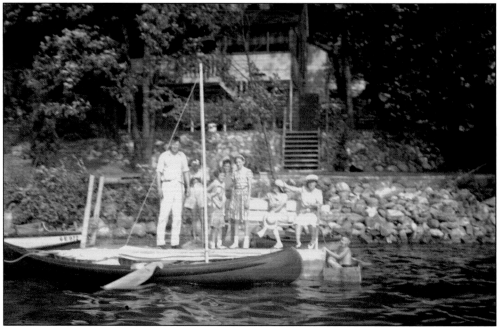

From left to right are (first row) Connie Markert; (second row) Everett King, Margaret King, Gretchen Baker, Glenna Markert, Harriet King, Hattie King, Mrs. Young, and Arthur Buehler. Margaret examines her hands for blisters after a sailboat race in the late 1930s. Behind them on the east shore is the King cottage, named the Four Kings.

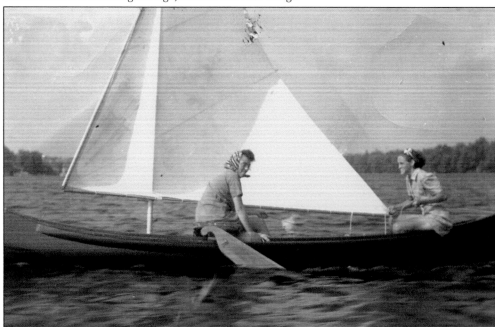

Glenna Markert (left) and Margaret King sail in a canoe fitted with a sail and leeboards in the late 1930s. A paddle-shaped leeboard, pictured on the side of the boat sheltered from the wind, prevents the boat from drifting leeward. Leeboards are used instead of a keel. Margaret remembers taking her younger sister Harriet to work at Rau's Pavilion by motorboat.

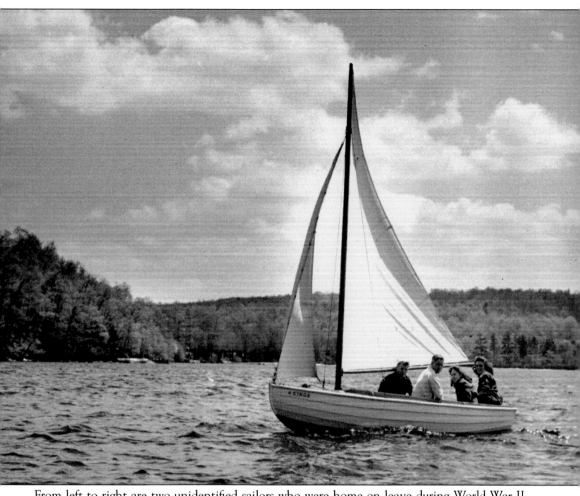

From left to right are two unidentified sailors who were home on leave during World War II, Ruth Bennett, and Margaret King in Sertl's sailboat, the *4 Kings*. Sailboat races and yacht club activities were suspended from 1942 through 1945, as many club members served their country. Spirits were high when races resumed in 1946, and over 30 boats were registered to race with as many as nine different starting times. It was at this time that the starting line was moved from Rau's Pavilion to Parley Patten's dock on Syndicate Point. Margaret King designed a Crystal Lake Yacht Club emblem and flag to fly from Patten's dock on race days. Margaret's father, Everett King, would wait for the last boat to cross the finish line, and then tally the scores. In 1948, a crash boat and crew was organized to rescue skippers and tow boats when needed.

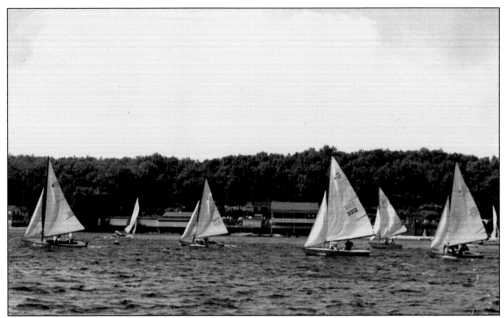

In this c. 1957 race, sailboats glide by Jack's Pavilion. Sailors, from left to right, are (first row) unidentified, Nancy Bantle, Leon Dickinson, and Frank Vitullo. Honorary commodore of the Crystal Lake Yacht Club Jack Yedziniak hosted an end of the season picnic at the pavilion in September 1957, at which Bantle was awarded first pennant for Comet Class B; Vitullo won the consolation race; and Dickinson won the pirate race.

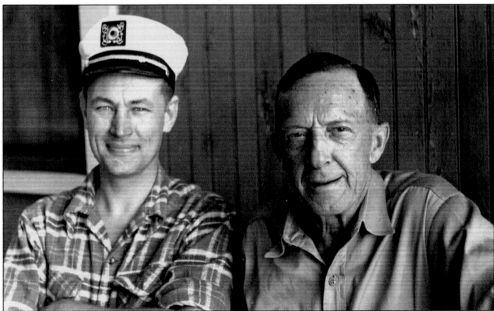

Pictured are Capt. Theodore Ragl (left) and Avery Andrews, who resided on the west shore. Ragl and Commodore Fred Gilbert received Dry Sailor awards from the Crystal Lake Yacht Club after their boats capsized in a race on a white-capped lake on July 1, 1956. Heavy winds toppled Gilbert's Comet, and Ragl's Snipe soon followed. Gilbert's boat was towed, but Ragl managed to right his boat and finish the race.

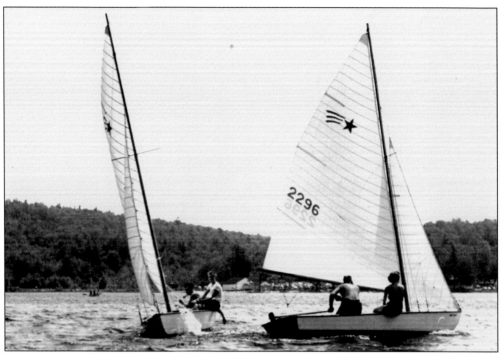

From left to right, Fred and Walter Gilbert and Leroy and Connie Markert race their Comets off the shore of Sandy Beach in this 1960s photograph. Leroy Markert was commodore of the Crystal Lake Yacht Club in 1950, Fred Gilbert in 1956. When the club revived in 1956 after a lack of interest in the previous two seasons, the Comet class was split into A and B classes.

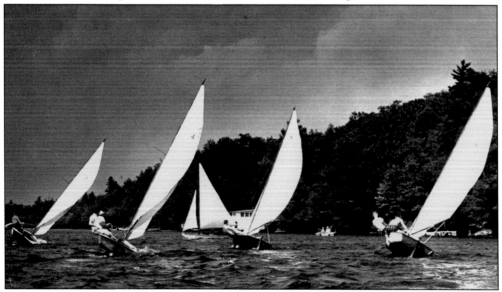

From left to right, Leroy Markert, William Weber, Frank Vitullo, ? Stiles, and ? Gilbert started the 25th racing season off on Sunday, July 1, 1962, in a brisk north wind. At the end of the 1962 season, the Weber trophy for first place in the overall class went to Robert Markert, the Yedziniak trophy for second overall to Freeman Patten, and the Markert trophy for third place to Jack Patten.

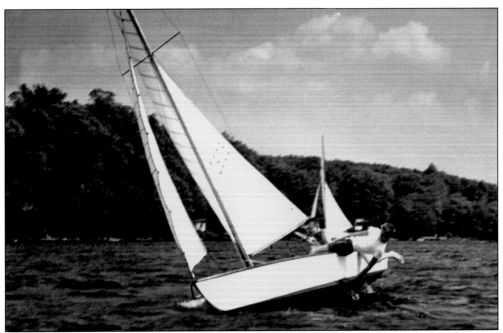

Fred (left) and Walter Gilbert race around 1962. When Fred Gilbert was yacht club commodore in 1956, he proposed the creation of a junior division that would encourage young people to own and race their own boats. The Rainbow Fleet was established, named after the colorful sails on the young skippers' boats, and their first race was held in 1957.

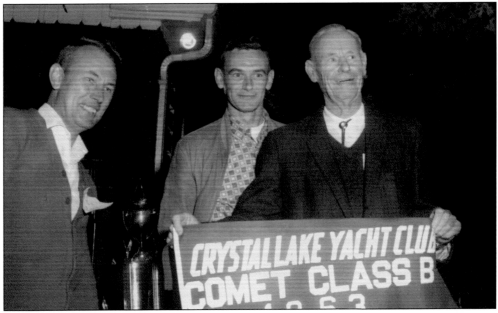

The annual September picnic of the Crystal Lake Yacht Club was held at the home of George Grennan and his wife in September 1963. Pictured are, from left to right, Ted Ragl, 1958 commodore; Freeman Patten, 1963 commodore; and Parley Patten, 1948 commodore. Parley Patten was awarded third place in the Comet Class B, Freeman Patten retired as commodore, and Ragl retired as race committee chairman.

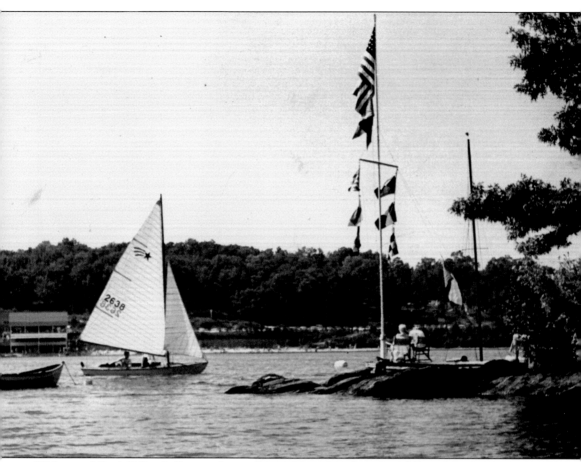

Walter and Fred Gilbert's Comet class sailboat approaches the colorful flags at Parley Patten's dock on Syndicate Point. Jack's Pavilion on the west shore is on the left of this 1960s photograph. Fred Gilbert had been commodore of the Crystal Lake Yacht Club in 1956. Races started at Syndicate Point and ran a triangular course twice around the lake for a total of about three miles. The boats varied in size and sail area, so the races were run on a handicap basis. The boats with the small sail area started off first. The point was known as Syndicate Point because executives of the Stafford textile industry, or syndicate, built their summer cottages here. Patten was the treasurer of the Standard Card Clothing Company in Stafford. Stafford's location on the tributaries of the Willimantic River meant that it had access to waterpower, and it became well known for its textile mills.

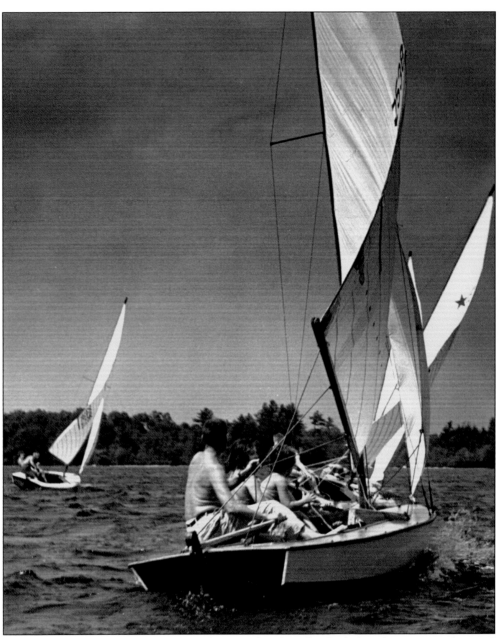

Unidentified crews race in this 1960s photograph. The 4th of July hot dog roasts and annual Labor Day weekend picnics were cherished traditions for Crystal Lake Yacht Club members. According to a column by "Barnacle Bill" in a local newspaper, a "pirate race" that was a version of the children's game of tag was to be held at the annual September 1956 picnic. A Coast Guard cutter, played by Edward Stiles, would start the activity and pursue the other boats on the lake, who would try to elude the "Coast Guard." The cutter would catch a pirate by sailing close enough to toss a ball into the cockpit of a pirate's boat. The captured pirate would then become a Coast Guard cutter and pursue his own pirates. Red flags flying from the ends of the booms would identify the pursuing cutters. Barnacle Bill recommended that a crew with a "true aim" and several tennis-sized or larger balls were essential equipment.

Eight

JIMMY'S

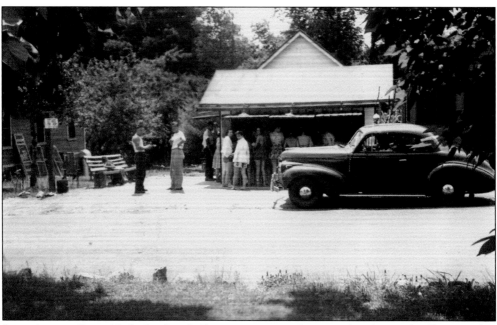

Jimmy's was a Crystal Lake landmark. Four generations of summer beachgoers fondly remember the hot dogs, hamburgers, soda, and ice cream served at the stand on Sandy Beach Road. Opened in 1929 by James and Selma Gross and their daughter Shirley, it stayed in business until Shirley Gross's retirement in 2004. By that time, she had worked there for 76 years. James Gross started his business at the lake during the Great Depression. The business he had managed, the Laurel Silk Hosiery Company in West Hartford, failed. Gross took the advice of his in-laws, the Rosenthals, and opened a hot dog stand across from their cottage at the lake. The stand was popular right from the beginning, as this photograph shows. The family also rented cottages, as advertised on the sign on the post at the left.

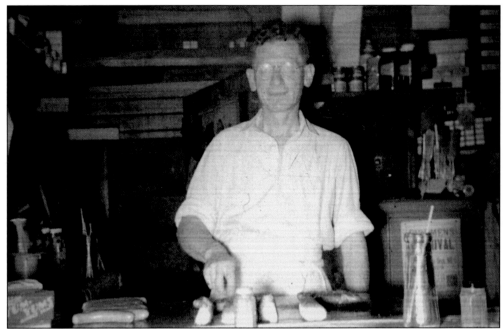

Cooking was done on a kerosene stove and makeshift grill by James Gross, pictured here in 1938. Ice cream had to be packed in ice and rock salt because Jimmy's did not have a freezer in those days. Hot dogs cost 15¢. Penny candy, such as the fruit-flavored Yum-Yums in the box on the counter, was a favorite, as were Jimmy's sugar cones and Coca-Cola brand soda.

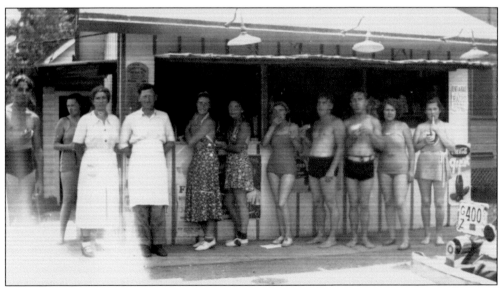

From left to right, dressed in white, Selma Gross, James Gross, Shirley Gross, and several unidentified customers enjoy their hot dogs and soda while posing for the camera. A sign on the post on the right reads, "Rent a bike at Rau's." Before Shirley started to manage Jimmy's in 1940, when her father found work at Consolidated Cigar, she hosted a program for homemakers on the *Hartford Times'* radio station, WTHT.

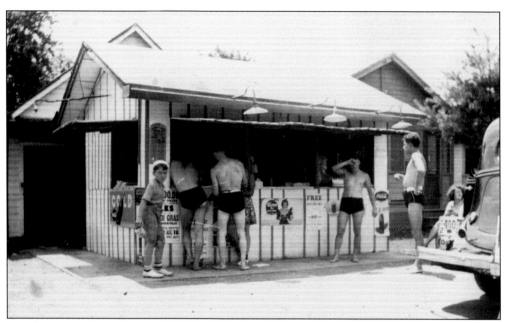

On this summer day, the temperature on the thermometer above the head of the boy with the white cap cannot quite be read, but one of Jimmy's customers wipes his brow. Signs advertise cold Coca-Cola, Hires root beer, and grape Nehi, favored by Radar O'Reilly of the television series *M*A*S*H*. Another sign announces a Mardi Gras on August 16 in Rockville, sponsored by the Benevolent and Protective Order of Elks.

Chrystal Skinner, great-granddaughter of 19th-century Crystal Lake settlers Lucius Aborn and Caroline Richardson, rides a pony named Ginger while visiting James Gross in front of Jimmy's hot dog stand around 1936. Chrystal spent summers with her grandparents at the Aborn farm near the lake. Behind them is the first Methodist parsonage in New England, which was used as a private home at that time.

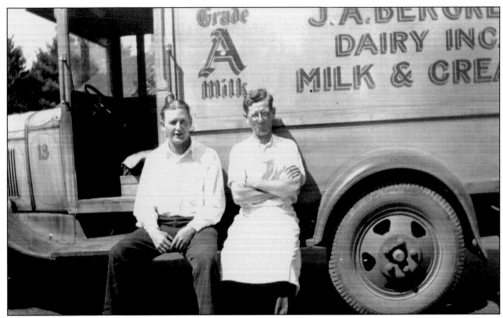

Walter Johnson and James Gross are seated on the running board of Johnson's J.A. Bergren's Dairy delivery truck. Bergren's was located on Burnside Avenue in East Hartford, where Generis Caterers in now located. Johnson began his career delivering milk and retired as an executive of Bergren's. One of the organizers of the Connecticut Boxing Guild, he had a stable of boxers in the 1930s, when amateur boxing was very popular at the Sandy Beach open-air arena.

The camera caught Stanley "Lefty" Bray relaxing on Jimmy's bench while on vacation at the lake in the 1930s. Bray, a lifelong Manchester resident, was a track star at Manchester High School. For over 50 years, he contributed to local athletic teams and athletes and was an official of the Manchester Road Race. Next to Bray, the roadside Bond Bread sign names the special of the day, orange-pineapple ice cream.

Shirley Gross stands by Sandy Beach Road in front of Jimmy's holding towheaded Caroline Connelly. A sign at the top of the pole behind them advertises Newgate ginger ale, which was made by an Enfield soda-bottling business. The poster behind Gross's hat promotes the current films at the Palace Theater in Rockville, seven miles away.

Jimmy's iconic ice-cream cone stands by the roadside in 1939. From left to right, Carrie ?, Selma Gross, Adolph Rosenthal, Inga ?, and Annie ? sit under the 5¢ sign advertising Coca-Cola. Rosenthal came from East Hartford to help his sister Selma run Jimmy's during the busy summer season.

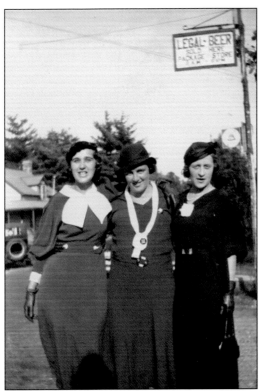

By the 1930s, many employers in the United States were offering paid vacations to working men and women. This photograph, taken in 1933, is marked "Girls from Rockville in Angelo's cottage." The girls are, from left to right, 19-year-old Elizabeth May, Catherine McGuane, and an unidentified friend. Note the hats, gloves, and purses accessorizing their best dresses.

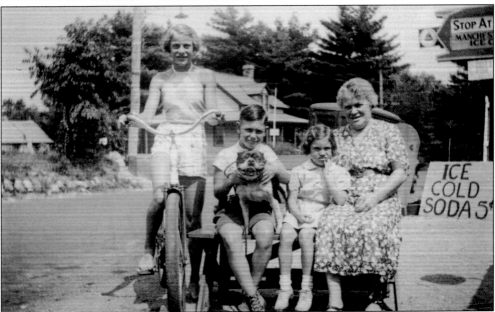

The Bonans are, from left to right, Elizabeth, her cousin Robert, her sister Virginia, and her mother Emily. They spent the summer of 1935 at a cottage near Jimmy's while Emily's husband visited relatives in Italy. Although Prince looks ferocious, Elizabeth remembers him as a gentle dog. Years later, she and her future husband, Alfred Judge, would roller-skate at the Sandy Beach rink and stop at Jimmy's afterwards.

Young Shirley Gross poses among the signs in front of Jimmy's in the early 1930s. Even without these large advertisements, loyal customers and word of mouth attracted people in droves. The sign above the beer sign advertises the ever popular penny candy. In these days of ubiquitous cell phones, the Bell Telephone sign at the top of the pole, advertising a telephone on the premises, would not attract much attention.

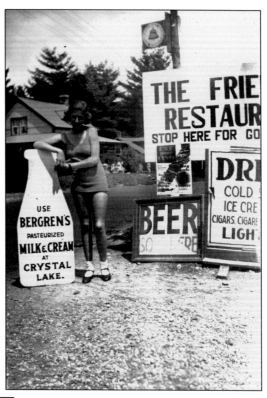

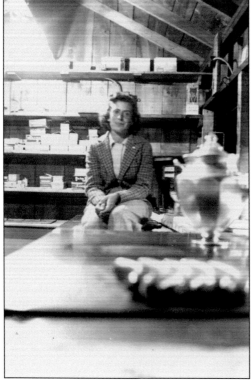

Jimmy's was open every summer from Memorial Day to Labor Day. In this photograph, Gross sits behind the grill on which Jimmy's famous hot dogs are sizzling. She loved the children who came to the stand, and although all her customers were treated like stars, she remembered one who really was. Actor Paul Newman stopped by for a meal on his way to the Stafford Motor Speedway in the 1980s.

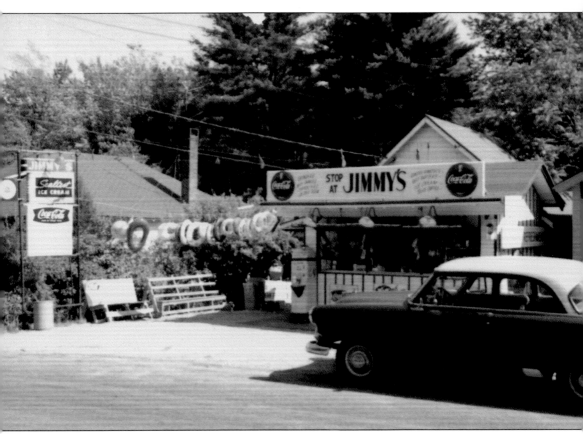

Not much changed over the decades at Jimmy's. The stand is still painted with red and white stripes in this October 1960 photograph, but the car parked in front is a newer model, and the signs are larger and brighter. Inflatable swim tubes hang from a rope. Cheeseburgers with peppers and onions, cooked by Shirley Gross, had become a favorite choice on the menu. Jimmy's and the Crystal Package Store both sold cigarettes and beer. From the 1940s to the 1960s, the package store participated in the annual Miss Rheingold contest. Customers could vote for their choice for Miss Rheingold, who would represent the New York brewery for the coming year. Interest ran high in the contest, and customers voted early and often. The company claimed that total votes one year approached 25 million, second only to the turnout for presidential elections. Shirley Gross kept Jimmy's open for 44 more years after this photograph was taken. One can still see the stand and its faded sign, but Shirley Gross and the thousands of customers she served over the years are gone.

Nine

THE TOWN

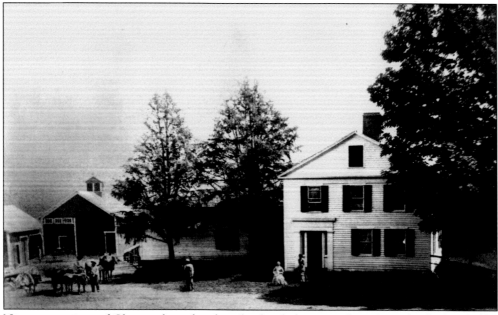

Nine generations of Charters have lived in the family homestead on Crystal Lake Road, also known as Lake Bonair Road and Route 140. In this *c.* 1890 photograph are, from left to right, unidentified farm laborers; Alfred Uriah Charter (holding whip, center); Charter's mother, Ruth Webster Charter (seated); and Charter's wife, Hattie Lewis Charter. Farming was a way of life in the 19th century. The majority of heads of households in Ellington listed their occupation as farmer in the United States census of 1890. There were more than 20,000 farms in Connecticut in the 1890 census of agriculture and only about 4,000 in the 2002 census. Farming was not an easy life. The dark-colored barn was destroyed in the Hurricane of 1938. Kerosene lamps were used for light until the Charter farmhouse got electricity in 1947. The large tree on the right blew down during a storm in September 1985. The house is now occupied by the Ludwigs, ninth generation descendants of John Charter, who bought the homestead and 148 acres of land from Nathaniel Grant of Windsor in 1753.

This ancient metamorphic rock is located on the Charter farm, in the uplands of what is known geologically as the Ellington quadrangle. In the 1930s, the Charters and their neighbors, the Willises, spent the long summer days outside. In those days of simple pleasures, they would climb onto the rock and savor the first radishes and cucumbers from the garden or crack nuts from the nearby hickory trees.

Both broadleaf and shade tobacco, grown under loosely-woven white netting, were important crops in the Connecticut River Valley. This photograph was taken in 1911 in the field behind the Charter homestead. There are four people, including farmer Alfred Charter, hidden among the tobacco plants. Some of the tobacco has already been harvested and is lying limp in the field.

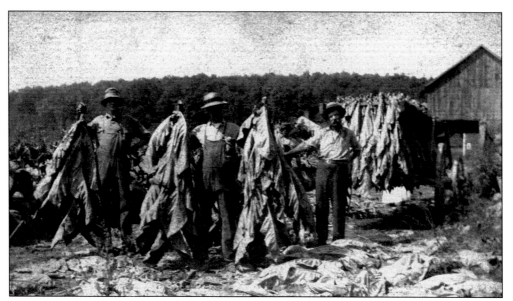

Workers on the Charter farm hold freshly harvested tobacco plants. The stalks were hung in the barn to cure. Dorothy Charter Olender, who grew up on the farm, remembered the family making charcoal, which was burned in the barns to help dry the tobacco. The value of the tobacco sheds destroyed in Connecticut during the Hurricane of 1938 was estimated at $4.5 million.

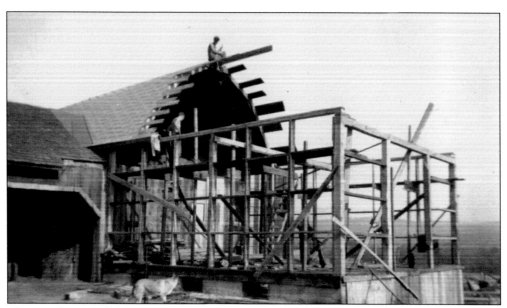

The new barn under construction on the Charter farm in this photograph in 1951 replaced a barn that was blown down in the 1938 hurricane. The tobacco crop was the hardest hit of all the agricultural crops. The hurricane struck on September 21, 1938, when Connecticut's tobacco crop was harvested and curing in the sheds. The crop loss was placed at $3 million by the Connecticut Department of Agriculture.

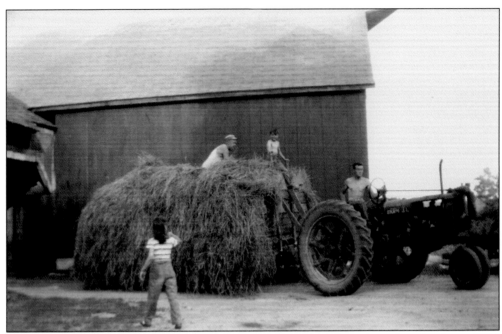

Pitching hay is hard work, and the hay can be prickly and itchy on bare skin. In this *c.* 1953 photograph, four members of the Ludwig family are getting ready to pitch a load of hay from the wagon into the hayloft of the new barn on the Charter farm. From left to right are Norma, Harris, Ronald, and Edward Jr., who is driving the Farmall tractor.

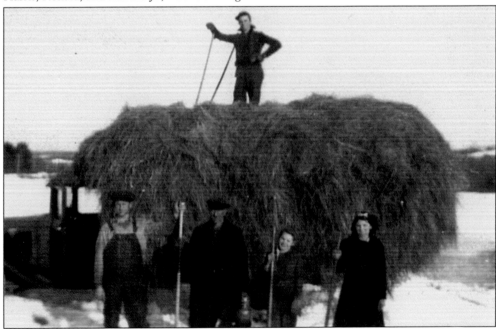

This load of hay was harvested on the Minor farm in the early 1940s. From left to right are (first row) Kenneth Minor, Arthur Minor, Delphine Willis, and Barbara Willis. George Minor is standing on top of the hay. Delphine recollects filling the barn to the top with hay and jumping in it. The dry hay in the loft would be pitched down to feed the farm animals during the winter.

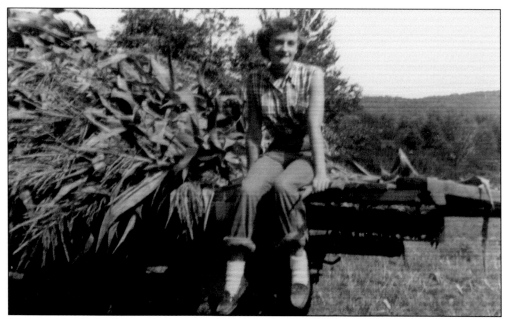

Charlotte Ludwig takes a break during the September 1953 corn harvest. Ludwig, who lived on the Charter farm during the Great Depression, says that the family was self sufficient. There were pigs, chickens, and cows to provide meat, eggs, and milk. For those necessities that they did not produce, they would call in a grocery list to Sam Yazmer's store in downtown Ellington, who would deliver the order.

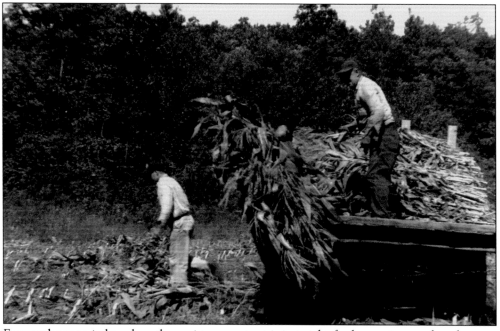

Farmers have to judge when the moisture content is just right for harvesting, so that the corn silage will be properly fermented and preserved to produce a high-quality feed for their cows. In this photograph, James Trench (left) and Harris Ludwig are harvesting corn on the Charter farm in September 1953.

Corn silage is an excellent energy source for dairy cows, encouraging high milk production. The corn needs to be chopped fine enough to pack properly for good fermentation. Farmers have to fill silos quickly after the corn is chopped to prevent spoilage. Here James Trench (left) and Harris Ludwig chop corn on the Charter farm.

In this undated photograph, large logs (left) and cows from the Minor farm on Minor Hill Road can be seen behind the fence. Agnes Minor Limberger remembers her father's sawmill. Many farms had their own sawmills, and often their own icehouses. Sawdust from the mill would be packed around the blocks of ice to keep them from melting.

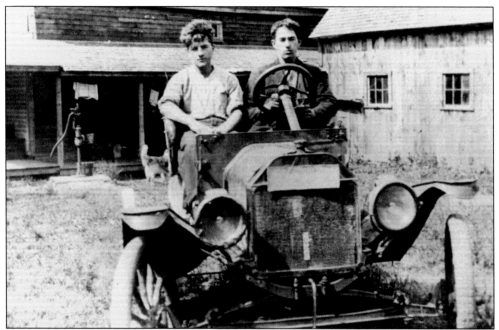

Brothers Thomas and Francis Minor pose in a car that was built from scratch by Francis in 1914. Note the pump outside of the Minor farmhouse on Minor Hill Road. Before the days of indoor plumbing, people got their water from wells with hand-powered water pumps. Pumping water from the well was a chore often assigned to children at home and at school.

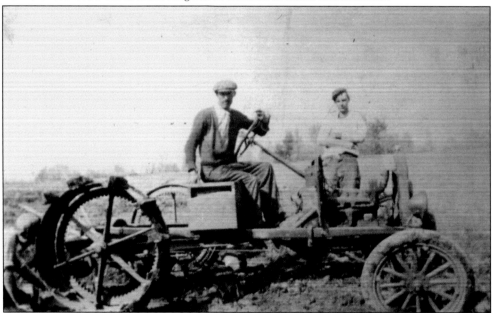

This tractor was built by Francis Minor (left) and his son Thomas, pictured here around 1935. Francis's daughter Agnes recalls the big garden that her father planted for his eight children. There was always plenty of vegetables in the summer, and hundreds of jars were canned for the winter. The Minors picked blueberries for Krause's Bakery in Rockville, and many remember the bakery's scrumptious baked goods.

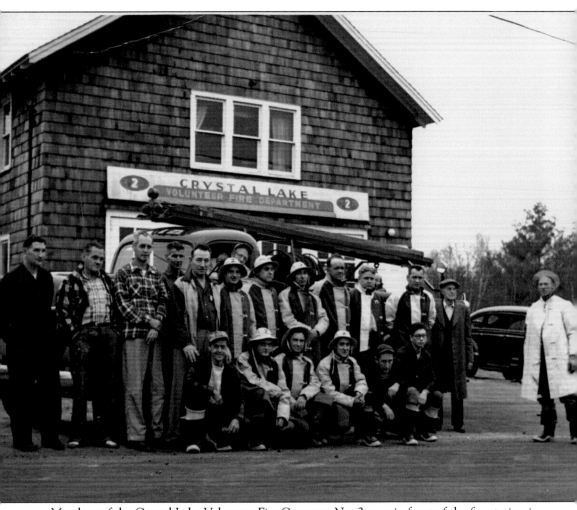

Members of the Crystal Lake Volunteer Fire Company No. 2 pose in front of the fire station in 1953. The half acre of land for the station was purchased on Sandy Beach Road in 1936. William Bowler, owner of the Crystal Lake Hotel, donated the hotel's icehouse to the department. It was converted into this one-bay station. Lawrence Fisher, who was fire chief from 1951 to 1955, is on the right wearing the light-colored gear. The firemen are, from left to right, (first row) three unidentified, Raymond Heintz, Matthew Ostrowski, and Richard Hamer; (second row) unidentified, John Marushan, Thomas Burns, Harry Ludwig, Henry Bolduc, unidentified, Earl Rich, and Milo Hayes; (third row) Roger Danchunk, Willis Scribner, Arthur ?, unidentified, and Martin Glode. In the early 1950s, there were several drownings at the lake, and there was no resuscitator available. Earl Rich began a fund drive to purchase one. Customers at his store, the Triangle Grocery, were among those who contributed. The resuscitator that was purchased saved many lives. Rich was named to the Ellington Wall of Honor in 2002.

CHARTER MEMBERS.

⌐OF THE ∟
CRYSTAL LAKE VOL. FIRE CO. NO. 2.
ELLINGTON ~ CONN.,

AVERY ANDREWS	RALPH LIPMAN
EDWIN BAKER	SAM. LIPMAN
GEORGE BOKIS	ARTHUR LOCKWOOD
WILLIAM COOKE	EDWARD LUDWIG
JOHN COOKE	PAUL MANCINI
LEON CONE	THOMAS MINOR
THOMAS DANEHY	ARTHUR MINOR
WILTON DIMOCK	WARREN NEFF
BURT FULLER	JOHN SHANNAHAN
CHARLES FIRTION	WALTON SKINNER
JAMES GROSS	WALTER SKINNER
SAM. GEER	PAUL HLASNEY
WILLIAM HEINTZ	SCOTT VINING
PHILO KIBBE	RAYMOND A. WILLIS
ARTHUR KIBBE	RAYMOND G. WILLIS
PHILO KIBBE JR.	ALFRED J. WILLIS
FRED MINOR	WILLIAM WITINOK
LEOPOLD KRAUSE	

ORGANIZED AUG. 27, 1934
CRYSTAL LAKE

The Crystal Lake Volunteer Fire Company No. 2 was organized on August 27, 1934, and the occasion is commemorated by this plaque with the names of the 35 charter members. Edward Ludwig was the first fire chief and served for 10 years. There was a need for a local fire department after several cottages and barns were destroyed because departments from neighboring towns could not get to them in time. Equipment was purchased with donations and was stored in a member's garage. In the summer of 1937, Chief Ludwig asked for volunteers to contribute money or skilled carpenters to help with the construction of a two-story, 26-by-36-foot firehouse. The first floor was used for equipment and the second for meetings. Fire insurance rates for cottages dropped after the new fire company was formed because the equipment could get to anywhere in the lake area in record time.

The Crystal Lake Volunteer Fire Company was incorporated by the State of Connecticut in 1935. This receipt for the $15 incorporation fee was made out to George Bokis and Edward Ludwig. The first fire trucks were a donated Reo, built by the Reo Motor Car Company of Michigan, and a dry cleaning truck. They were converted into firefighting vehicles.

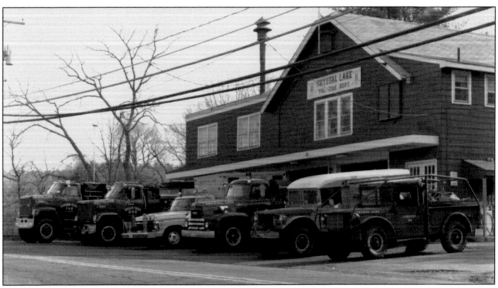

The first big blaze fought by the Crystal Lake Volunteer Fire Company was the fire that destroyed the Crystal Lake Hotel in 1935. The new company, being the closest, was the first to answer the alarm. The volunteers had only two small pumps and a one-and-a-half-inch hose. The firemen had more equipment in this undated photograph, and today the volunteers have tankers, rescue vehicles, a forestry truck, and a rescue boat.

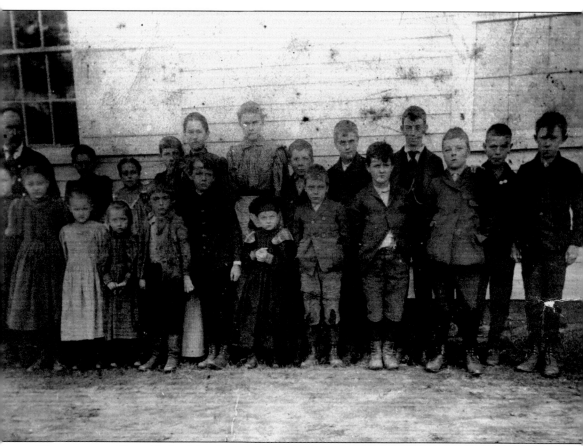

The one-room Crystal Lake School was built in 1861 on the corner of White Road and Sandy Beach Road. Martha "Mattie" Aborn accepted her first teaching assignment at the school in 1893, when she was 20 years old. Five of teacher Myron Dimock's nine children were in the class pictured here in 1896. From left to right are (first row) Elna Dimock, Flossie Baker, Bernice Dimock, Emma Carlson, Arthur Kibbe, Raymond Willis, Ora Charter, Claude Dimock, Everett Charter, Julius Richardson, and Bill Sullivan; (second row) teacher Myron Dimock, Lena Dimock, Bessie Neff, Myrtie Willis, Edna Dimock, Bessie Richardson, Clarence Newell, Everett Kibbe, and Earl Curtis. Myron Dimock was also the postmaster at the Crystal Lake Post Office from 1884 to 1908, which was called the Square Pond Post Office until 1889. A second schoolroom was added to the building in 1929. However, the school did not have inside bathrooms until much later. An article in the *Hartford Courant* on August 1, 1948, reported that $5,000 would be spent to improve the Crystal Lake School and install inside toilets.

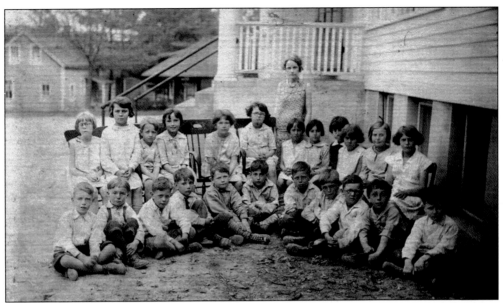

In this c. 1930 photograph, Mrs. Tattersall, teacher of grades one to four, stands behind her students at the Crystal Lake School. From left to right are (first row) Nathan Kies, Eugene Minor, Donald Neff, Marvin Kibbe, unidentified, William Amprimo, Walter Neff, Clarence Campbell, Clayton Willis, Henry Minor, and Russell Heintz; (second row) unidentified, Helen Maichuk, Norman Kies, unidentified, Louraine Willis, unidentified, unidentified, Ruth Lipman, Almira Amprimo, Viola Maichuk, Marjorie Willis, and Mary Maichuk.

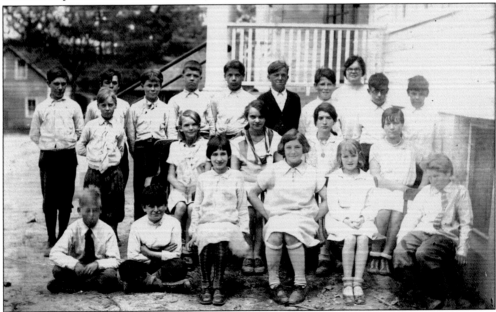

Pictured are Crystal Lake School students in grades five to eight around 1930. From left to right, are (first row) Otis Kies, George Lipman, Gladys Campbell, Omilean Willis, Leona Parker, Sophie Maichuk, Frances Lipman, Edna Parker, Ludmila Remenik, and Lawrence Kies; (second row) Philo Kibbe, Harry Truempy, Thomas Minor, Francis Willis, Milton Witinok, Adam Zebrowski, Louis Lipman, Walter Amprimo, Mrs. Kallen, Emil Truempy, and George Kies.

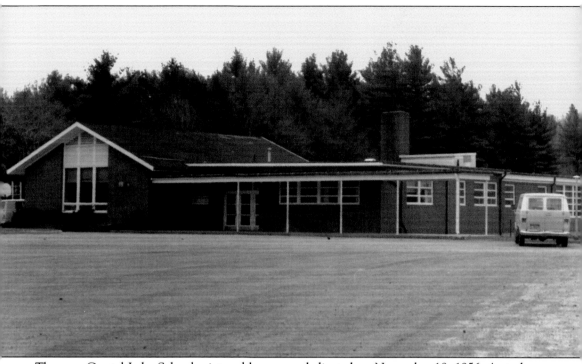

The new Crystal Lake School, pictured here, was dedicated on November 18, 1956. A study group had been formed in 1955 to investigate a new school for the Crystal Lake area. Those on the study group were William Wormstedt, Edith Scribner, Agnes Rich, Charles Bagnall, John McConville, Walter Neff, and Joseph Girardini. The study group became the building committee, and town voters approved the preliminary plans in December 1955. A few months later, $250,000 was appropriated to the committee and construction began. John MacVeagh was the principal when the new school opened. Although the school had only eight classrooms, it was designed with expansion in mind and has been enlarged and renovated since. At a 50th anniversary celebration held in April 2007, school administrators learned of the existence of a time capsule that had been sealed in the brick wall near the main office. When it was opened in June 2007, a copy of the November 18, 1956, *New York Times*, the contract for the school's construction, and signatures of all the staff and students were found.

Town of Ellington
Crystal Lake Honor Roll, World War II

Walter Amprimo	Norman Kies	James Soulia
William Amprimo	George Lipman	George Sullivan
Edward Anderson	Fred W. Meacham	William Sulyma
Everett A. Bradway	George Minor	John P. Sweeney
Clarence Campbell	Henry W. Minor	Everett Thuemmler
Doris Clark	Frank H. Morganson	Philip Tolisano
Eugene N. Conklin	Walter T. Nagorka	Emil Truempy
William H. Cooke	Alden P. Neff	David White
Harvey Deane	Donald E. Neff	Lewis H. White
Sigfried Gilbert	Walter H. Neff	R. Alfred Willis
Robert Green	Peter Parsain	Clayton Willis
Russell P. Heintz	Roy W. Partelo	Dorsey A. Willis
Joseph Hlasny	Earl A. Rich	Francis E. Willis
Robert Holland	Edward Roberts	Kenneth G. Willis
John Jahne	Napolean Roberts	Theodore Zaushny
Otis Kies	Anton Sedlacek	William Zipperling
	William Sedlacek ★	
	William Spusta	

The Town of Ellington and the Crystal Lake Association honored those who served in World War II when they dedicated Veteran's Memorial Park on Monday, September 6, 1993. The town's public works department closed off Skinner Road and did the site work, and the lake association paid for the bronze plaque listing the 50 citizens who served in the war. The plaque is mounted on a rock in the park, which is located at the corner of Sandy Beach Road and West Shore Road. The program that Labor Day began with a welcome from Robert K. Pagani, a lake resident and member of the Ellington Board of Selectmen. Pastor John E. Post of the Crystal Lake Community United Methodist Church delivered the invocation and benediction and John Darcey sang "God Bless America." Boy Scout Troop 96 raised and lowered the American flag. After the presentation of the plaque by Walter Moody of the lake association and first selectman Donald Landmann, a roll call of veterans was read.

Ten

SANDY BEACH

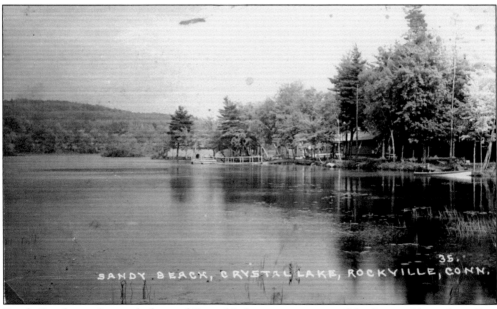

SANDY BEACH, CRYSTAL LAKE, ROCKVILLE, CONN.

Sandy Beach, on the south shore of Crystal Lake, was once part of the Lucius Aborn farm. Part of Sandy Beach Road, which passes south of the lake northeast toward the Stafford town line, runs along a 17th-century Nipmuc Indian path. A front-page story in the November 6, 1925, *Rockville Leader* reported the sale of Sandy Beach to George D. Bokis. Bokis had leased the property from William Bowler for several years. The newspaper article states that Sandy Beach had become a very popular summer resort under the management of George Bokis and his wife Nellie. The property included a pine grove, dance hall, refreshment pavilion, bathhouses, and a canoe locker. The dance hall was also used as a roller-skating rink. An open-air boxing arena was added, where matches were held from May to September.

These unidentified men pose around 1920 in their wool tank suits with their boat near Sandy Beach. The 183-acre lake is shallow for a good distance out from Sandy Beach, making it an ideal swimming spot, but there is a drop off nearby that soon reaches the lake's maximum depth of 42 feet.

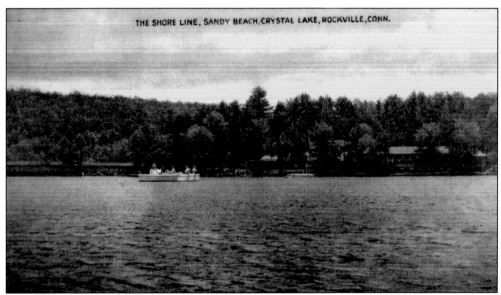

In this c. 1930 postcard, the pine grove still shades the buildings at Sandy Beach. This scene changed forever after the Hurricane of 1938, which destroyed the grove. In addition to recreation, Crystal Lake has always been a fisherman's paradise. In 1891, C. H. Starry, who drove the stage between Rockville and Tolland, caught a nearly seven-pound bass. The fish was put on display in the window of Fitton's Pharmacy in Rockville.

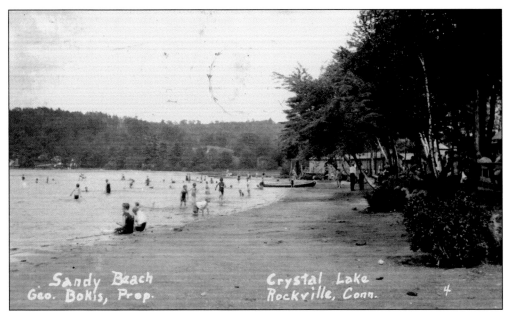

Sandy Beach
Geo. Bokis, Prop.

Crystal Lake
Rockville, Conn.

4

This photograph of Sandy Beach was taken before the waterslide was built. It was at about this time, in June 1934, that a violent storm blew the roof off of a 10-by-50-foot bathhouse. According to a newspaper report at the time, the roof landed in the lake about 15 yards away.

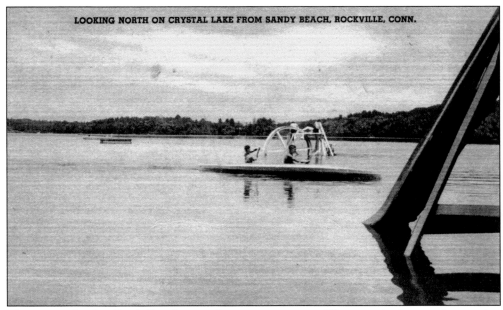

LOOKING NORTH ON CRYSTAL LAKE FROM SANDY BEACH, ROCKVILLE, CONN.

This water wheel at Sandy Beach was a favorite amusement. Water carnivals were also popular. Phil Tolisano recalled a contest held between teams from Stafford and Rockville in the 1940s. As the teams struggled to get a greased watermelon to shore, Rockville's strategy was to get the melon to the bottom of the lake and rub it with sand to get rid of the grease. It worked, and Rockville won.

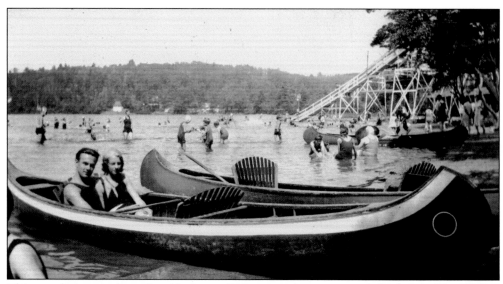

This couple is seated comfortably in an 18-foot wooden canoe with backrests. The 50-foot waterslide behind them in this *c.* 1940 photograph seems like it would have been more at home at Coney Island than Sandy Beach. It cost 10¢ to enter the beach to swim, but George D. Bokis would let Crystal Lake children that he knew enter free.

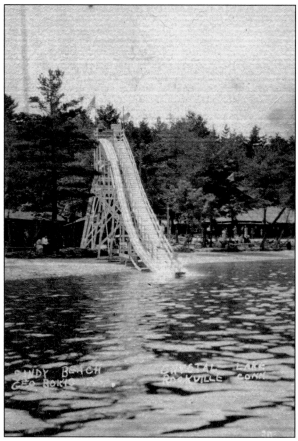

The huge waterslide dominates the beachfront. In the years after George D. Bokis's purchase of Sandy Beach in 1925, the former Lucius Aborn farm was transformed into a thriving resort community. Aborn's daughter, Martha "Mattie" Aborn Skinner, advertised building lots for sale, and cottages with lake views seemed to sprout from the sandy soil.

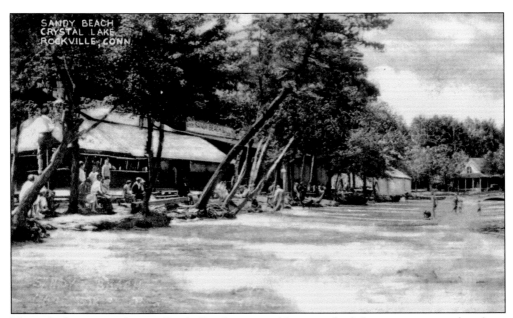

The refreshment pavilion at Sandy Beach, pictured here on the left, was a very popular place. To the right of the pavilion is the ballroom, which was used for both dancing and roller-skating in the 1930s and 1940s. Nearby summer residents could hear the music from the dance hall at night from their front porches.

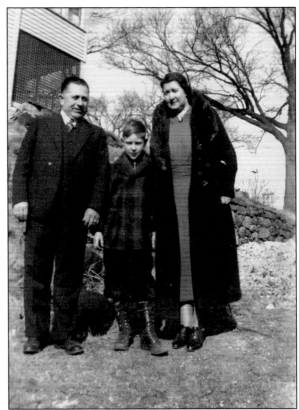

From left to right, George D. Bokis, his son George J. Bokis, and his wife Nellie Murphy Bokis pose at Sandy Beach around 1940. The younger George and his friend Phil Tolisano cleaned the powder off the floor of the dance hall so that it could be used for roller-skating and also helped out by selling peanuts and popcorn at the boxing arena.

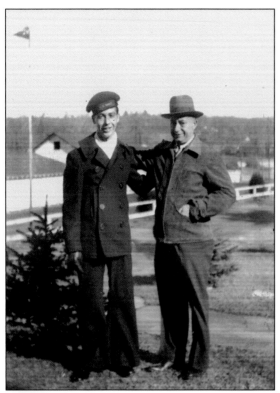

Phil Tolisano (left) and his father Ambrose "Red" Tolisano pose for a photograph while Phil, home on leave from the U.S. Navy in 1944, was visiting his father at Sandy Beach. Red Tolisano, who lived in Hartford, became friends with George D. Bokis and rented the bathhouse and canoe locker from him. He converted them into Red's Tavern and later the Pine Grille Inn.

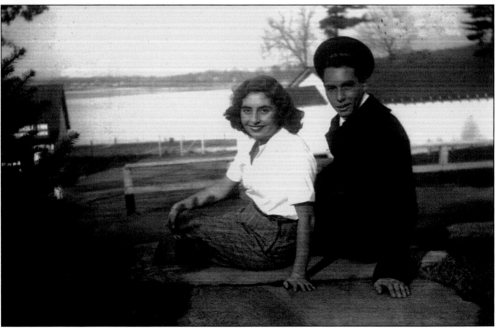

Josephine Tolisano (left) and her brother Phil are seated with Sandy Beach in the background around 1943. Their father's restaurant, the Pine Grille Inn, is just visible behind the tree at the left, and the dance hall and roller-skating rink is behind them. Phil said that he worked with his father behind the bar, and on hot days the beer tap was flowing constantly.

These postcard views of the interior of the Pine Grille Inn show signs of some of the many activities that drew people to Sandy Beach—food, boxing, and music. A sign next to the bar promotes Tuesday evening boxing matches. Waiters stand by a jukebox owned by Phil Tolisano's brother James. The sign on top advertises Ruppert Beer, a brewery owned by New York Yankees owner Jacob Ruppert Jr.

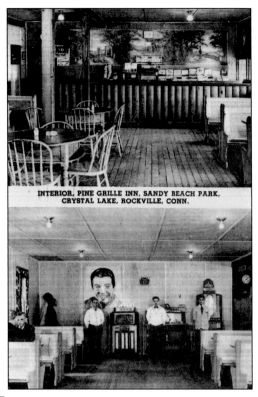

INTERIOR, PINE GRILLE INN, SANDY BEACH PARK,
CRYSTAL LAKE, ROCKVILLE, CONN.

The Tolisano home was across the street from the Pine Grille Inn. Martha Tolisano, pictured here on the front steps, was the cook. After she had gone home in the evening, her husband would put a white towel in the window of the restaurant to signal her if someone showed up for a late meal. She would watch for the towel and return to the restaurant to cook for the customer.

117

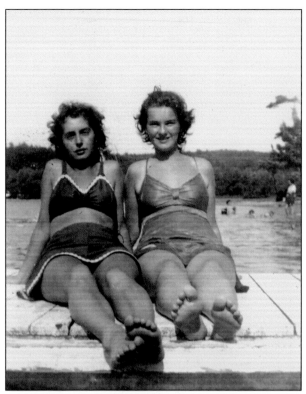

Josephine Tolisano (left) and Shirley Liebe sun themselves on the Sandy Beach raft after a swim. Shirley Liebe lived in Manchester but spent the summer at Crystal Lake. The friends worked together at Josephine's father's restaurant, the Pine Grille Inn. Liebe could serve beer, but Tolisano was younger and could not. Liebe loved to roller-skate and would save her money for the 50¢ fee.

These two pairs of skates spent many hours at the Sandy Beach roller-skating rink on the feet of Shirley Liebe and Russell Andrews. Andrews came to skate with his friends from Rockville. The couple began dating and would go to Jimmy's stand for a hot dog and orange drink after skating. They married in 1951, one of many couples who met their future partners at the lake.

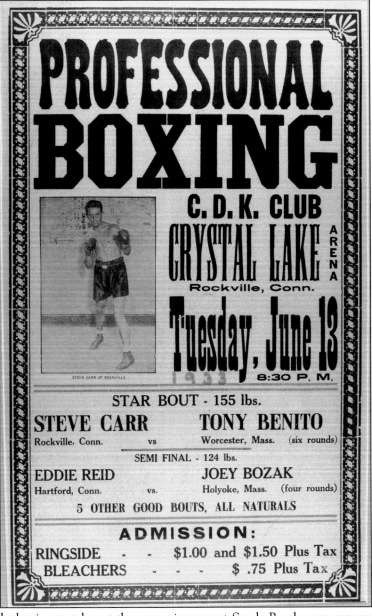

PROFESSIONAL BOXING

C. D. K. CLUB
CRYSTAL LAKE ARENA
Rockville, Conn.

Tuesday, June 13
1933
8:30 P. M.

STAR BOUT - 155 lbs.

STEVE CARR
Rockville, Conn.

vs.

TONY BENITO
Worcester, Mass. (six rounds)

SEMI FINAL - 124 lbs.

EDDIE REID
Hartford, Conn.

vs.

JOEY BOZAK
Holyoke, Mass. (four rounds)

5 OTHER GOOD BOUTS, ALL NATURALS

ADMISSION:

RINGSIDE - - $1.00 and $1.50 Plus Tax
BLEACHERS - - - $.75 Plus Tax

STEVE CARR OF ROCKVILLE

Tuesday night boxing matches at the open-air arena at Sandy Beach were very popular in the 1930s and 1940s. This poster advertises the six-round main bout on June 12, 1933, in which Steve Carr of Rockville was featured. Carr won the state amateur middleweight championship that year and turned professional. Attilio "Pop" Frassinelli of Stafford, who became lieutenant governor of the state of Connecticut, often refereed the matches. Phil Tolisano remembered that the bell rung at the matches was a brake drum hit by a hammer, which made a very loud clanging sound. Many local men boxed at Sandy Beach, including Tom Minor of Ellington; Charlie Backofen, "Count" Satryb, Billy Satryb, "Babe" Berriault, Nick Phillips, and Tony Phillips of Rockville; Sam Maltempo of Manchester; and George Bardini, Henry Periolo, and Larry Passardi of Stafford. These amateur boxers had other jobs to support themselves, as there was very little prize money in the sport. George D. Bokis sometimes paid the winner with a watch.

Good friends Phil Tolisano (left) and George J. "Toot" Bokis imitate the boxers at Sandy Beach arena. Bokis lived upstairs over the skating rink and dance floor that his father owned. There was a hole in the floor of an upstairs bedroom through which Bokis could spy on the activities below. Rainy Sundays hurt business, and Bokis remembers he could not even talk to his father if it rained on a Sunday.

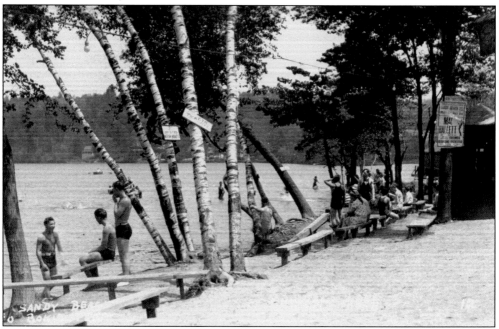

As bathers enjoy an afternoon swim, there is the promise of a lively evening ahead. The poster on the tree near the ticket booth advertises the appearance of Mal Hallett and the Columbia Recording Orchestra on May 30 at the Sandy Beach Ballroom. Hallett was a bandleader who was a pioneer in the swing band era and toured New England in the 1930s. Admission was 50¢.

Kayaking is still popular on Crystal Lake, which has a public boat launch on the west shore. George Liebe, pictured above in the 1940s, and his brother Robert, below, enjoyed kayaking during many happy summers spent at Crystal Lake. After rain ruined several day trips, the boys' grandfather Robert Liebe, who traveled to the lake by interurban trolley, wanted to have a place to stay in inclement weather. He built a cottage at the lake at a cost of $500. The boys' father, Osmond Liebe, was the owner of Liebe's Hardware, Wallpaper, and Paint store in Rockville. The business marked its 100th year in business in 2008.

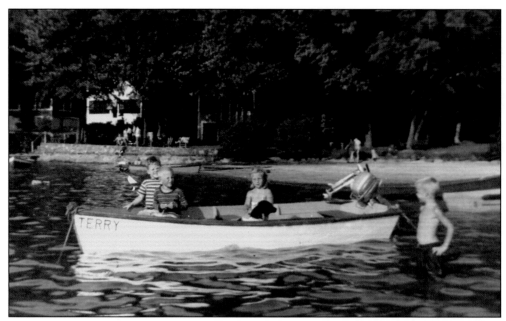

This 1948 photograph captures Teresa Smith and her dog Skippy in the boat named for her off the shore of the Smith family's summer cottage on Aborn Road near Sandy Beach. Teresa remembers when Hurricane Diane struck New England in August 1955. She, her mother, and grandmother went to stay with their neighbors, John and Ida Bressan, whose year-round house could better withstand the wind and rain than their cottage.

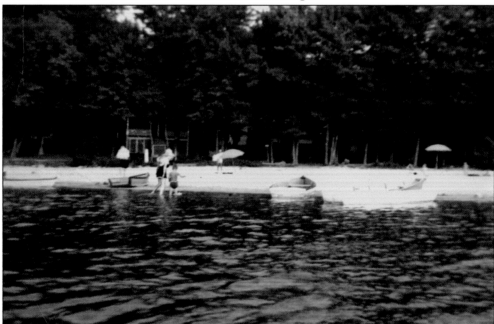

This beach to the northeast of Sandy Beach, pictured here in 1948, has been called by several names over the decades. The cottages in this area were set back from the beach. Some knew it as Silver Sands, others as Little Sandy, Second Sandy, or Aborn Beach. It is off Aborn Road and Aborn Private Road, which meet and join East Shore Road to the north.

The Town of Ellington purchased Sandy Beach from the estate of George D. Bokis in 1971. The dance hall and roller-skating rink had long been silent. Ellington first selectman Francis J. Prichard Jr. had long supported the acquisition and endorsed the purchase. The Ellington Board of Finance unanimously approved sending the $90,000 appropriation to town voters, who overwhelmingly authorized the expenditure in April 1971. The town then received the deed to the 10-acre property. Ellington Wall of Honor 2007 honoree Leonard Johnson was a student in Manchester in the 1940s and recalls his eighth-grade class trip to Sandy Beach. In 1972, Johnson was a member of the Community Development Action Plan committee, which received a grant to develop the beach. Under Kinsley Whittum's direction, the old buildings were razed. In this photograph, equipment can be seen at work on the beach through the spray of a passing boat. The beach was enlarged and fenced in, and a parking lot was added. The Rockville Fish and Game Club's lakeside clubhouse is on the right of the photograph.

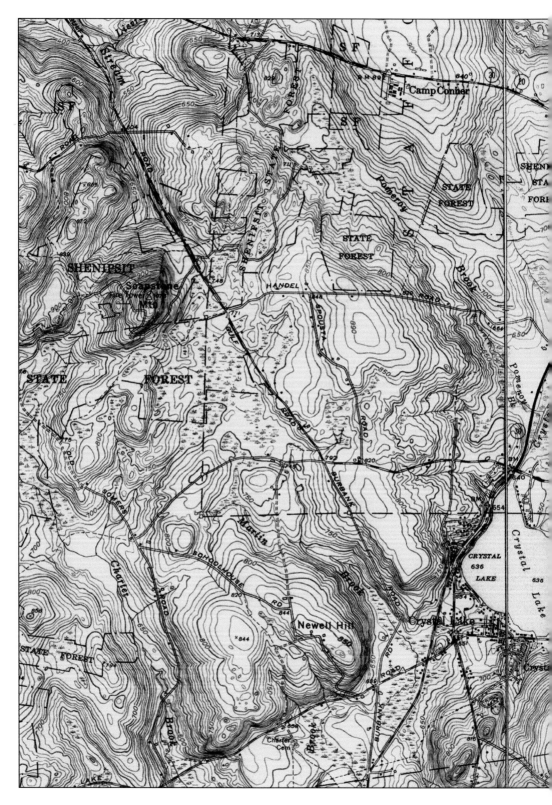

124

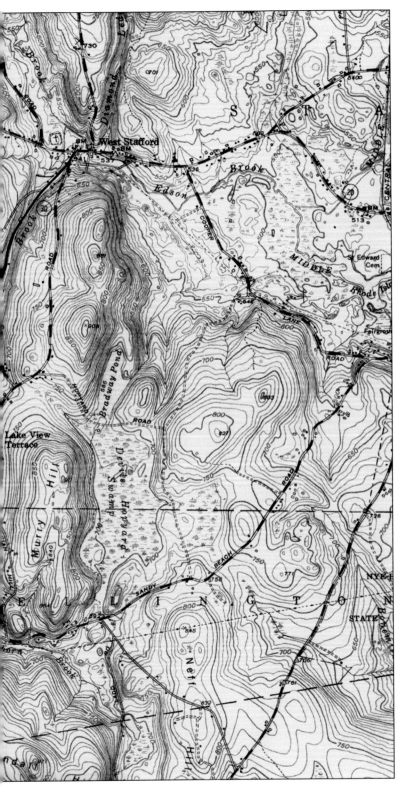

The U.S. Geological Survey began producing its topographic atlas of the United States in 1882. Crystal Lake lies partly in the Ellington quadrangle and partly in the Stafford Springs quadrangle. This 1952 map was made by combining two 7.5 minute series maps. A large part of the northern area of the map is the Shenipsit State Forest. The 7,000-acre forest lies in Ellington, Somers, and Stafford. The fire tower on 1,075-foot Soapstone Mountain on the upper left of the 1952 map has been replaced by an observation tower. Camp Conner, marked at the top of the map on Route 190, is now the location of the Eastern States Civilian Conservation Corps Museum. During the Great Depression, boys from ages 17 to 24 lived at the camp and built forest roads and buildings, some of which are still in use.

BIBLIOGRAPHY

Aron, Cindy Sondik. *Working at Play: A History of Vacations in the United States*. New York: Oxford University Press, 1999.

Cohen, Dorothy B. *Ellington: Chronicles of Change*. Ellington, CT: 1987.

Connecticut. *Catalogue of Connecticut Volunteer Organizations (Infantry, Cavalry, and Artillery) in the Service of the United States, 1861–1865: With Additional Enlistments, Casualties, Etc. Etc., and Brief Summaries, Showing the Operations and Service of the Several Regiments and Batteries*. Hartford, CT: Brown and Gross, 1869.

Dimick, Alan R. *Dimick Family History*. Self-published, 1992.

Eaton, Wm. C., and H. C. Osborn. *Map of Tolland County, Connecticut*. Philadelphia: Woodford and Bartlett, 1857.

Richardson, Merrick Abner. *Looking Back: An Autobiography*. Chicago: self-published, 1917.

Roster of Connecticut Volunteers Who Served in the War between the United States and Spain 1898–1899. Hartford, CT: Case, Lockwood and Brainard Company, 1899.

Stevens, Abel. *Memorials of the Early Progress of Methodism in the Eastern States: Comprising Biographical Notices of Its Preachers, Sketches of Its Primitive Churches, and Reminiscences of Its Early Struggles and Successes: Second Series*. New York: Carlton and Phillips, 1854.

United States Department of Agriculture. 1890 Census of Agriculture. http://www.agcensus.usda.gov/Publications/Historical_Publications/index.asp

United States Geological Survey. *Connecticut–Tolland County: Ellington Quadrangle*. 7.5 minute series. Washington, D.C.: United States Geological Survey, 1953. University of New Hampshire Library Digital Collections Initiative.

United States Geological Survey. *Connecticut–Tolland County: Stafford Springs Quadrangle*. 7.5 minute series. Washington, D.C.: United States Geological Survey, 1952. University of New Hampshire Library Digital Collections Initiative.

INDEX

Discover Thousands of Local History Books Featuring Millions of Vintage Images

Arcadia Publishing, the leading local history publisher in the United States, is committed to making history accessible and meaningful through publishing books that celebrate and preserve the heritage of America's people and places.

Find more books like this at
www.arcadiapublishing.com

Search for your hometown history, your old stomping grounds, and even your favorite sports team.